The Possibility of a World

JEAN-LUC NANCY

The Possibility of a World

Conversations with
Pierre-Philippe Jandin

TRANSLATED BY TRAVIS HOLLOWAY
AND FLOR MÉCHAIN

FORDHAM UNIVERSITY PRESS
New York ■ 2017

This book was first published in French under the title *La possibilité d'un monde: Dialogue avec Pierre-Philippe Jandin*, © Les petits Platons, Paris, 2013.

Fordham University Press has no responsibility for the persistence or accuracy of URLs for external or third-party Internet websites referred to in this publication and does not guarantee that any content on such websites is, or will remain, accurate or appropriate.

Fordham University Press also publishes its books in a variety of electronic formats. Some content that appears in print may not be available in electronic books.

Visit us online at www.fordhampress.com.

Library of Congress Cataloging-in-Publication Data available online at http://catalog.loc.gov.

Printed in the United States of America

19 18 17 5 4 3 2 1

First edition

Contents

In accordance with Jean-Luc Nancy's wishes, we have attempted to preserve the spontaneity of oral discussion. We therefore kept colloquial expressions and tried to avoid rewriting the recording altogether.

—Pierre-Philippe Jandin

Formative Years

PIERRE-PHILIPPE JANDIN: Knowing your taste for pastiche and parody, I'm almost tempted to introduce our discussion like Heidegger when he offers a biography of Aristotle: "Jean-Luc Nancy was born, he worked, and he's still working." Because it's very true that you demonstrate constant attention to the world—to our world, which has almost disappeared, and to the coming world. In any case, to understand your approach, and without mistaking "thinker" and "philosopher" for synonyms today, the academic question that presents itself is: How did you become a philosopher? Especially since you gave a lecture in 2002 at the Centre Pompidou entitled: "I Never Became a Philosopher." What's this non-becoming, then?

JEAN-LUC NANCY: The title of that talk was a bit provocative and presumptuous. But something suddenly struck me

when the Centre Pompidou posed this question:[1] I didn't become a philosopher because I've always been one. All that I've known, or all that I've experienced, took place against a background that I wouldn't call philosophical, though it's close to it—a background of interest in the things of thought, in conceptions.

P.-P.J.: I think you also speak about an experience of the uncanny felt in your relationship to the world; like when you were a child and rode in a car at night, you wondered where the trees, which were lit by the beams of the headlights, went once they were out of sight.

J.-L.N.: Many children ask themselves these kinds of questions. During my first years in Baden-Baden, I remember very well that when we returned home, we would walk up a street alongside a vast wrought iron fence that ran in front of several yards. The fence had these elaborate patterns, and I'd get lost in speculations about the necessity or non-necessity of all these adornments. I wondered whether it was necessary to make them or not, or what could be done with the metal that would be recuperated if all of these things were removed—the spectacle of these ornamentations wielded a sort of fascination. I believe there's something one can find in each of us that comes from having been a bit cut off from the world, without this being a painful or unhappy detachment, and at the same time without it being a sort of withdrawal. Very early on in life, I took great pleasure in walking in the countryside all alone, or with a dog I

1. All of the talks that were given on this theme have been published in the volume *La Vocation philosophique* (Paris: Bayard, 2004). These lectures were given at the Centre Pompidou in the context of the "Philosophy at the Centre" lecture series of the "Revues parlées" from January 2002 to January 2004.

adopted in high school, who became my companion. I still had friends and many acquaintances. But I've always had a taste for meandering alone in nature, or for being immersed in manual labor—for example, with the farmers from a neighboring farm where I enjoyed cutting tobacco, harvesting grapes, picking corn, and so on. I've always enjoyed manual labor for how it entails withdrawing from all of the rest of the world. When you're immersed in a material task, you start to think only about "How will I do this? Which way should I go? How should I chop the wood with my axe, or put the grapes in the basket?"—I felt all of this intensely. On the other hand, I've also always been totally absorbed while reading. For me, these two sensations are associated: In reading as well, there's a kind of solitude, a withdrawal, an entrance into another world that was, in my high school years, for example, the world of Balzac or Zola.

Philosophy was there at least in the form of thought for its own sake. A thought that wasn't applied to any determinate object. I did apply it to objects in the context of militant action—for example, to the *collège unique*,[2] to the democratization of education, or to biblical objects. But throughout all of this, there was perhaps no object. My taste was certainly frenzied and encyclopedic: I often read dictionaries, such as the two-volume *Grand Larousse*—for example, the illustration with the fortified castles. But it wasn't for the pleasure of learning—I never became a real savant. My

2. [Until 1975 in France, a school for students from roughly age 11 to 15 separated them into three groups, one of which allowed students to pursue more academic studies while the other two focused on vocational training. The reforms of the *collège unique* extended the legal age of schooling from age 14 to age 16 and required that all have access to the same education until roughly 16 years of age.—Trans.]

enjoyment was in seeing words like *machicolation, bartizan,* and so on. There was a taste for language, but this taste remained tied to what I would call a thought without an object, spinning in its own tracks.

P.-P.J.: You've been talking about the terms in which you first related to the world. I'd now like to ask you how the world was when you entered into it. By what path, which was more or less chosen, did you make your way into the world?

J.-L.N.: The world, when I entered into it, was the world of World War II. It's as if I'd been conceived at the start of the war in late 1939—I was born in July of 1940. But the date on which you're born doesn't have much overall importance because you aren't aware of the world you enter. I was born in the thick of war, in the occupied zone in Bordeaux. My parents had been forced to evacuate after the surrender of June 1940. Then I grew up there until the Liberation in 1945. The world of my early childhood is thus a bit unusual, the world of occupied France, but I was unaware of it. I have a very vague memory of hearing someone talking about the *Kommandantur* or the fact that a friend of my parents was in the resistance, which I learned only after the war of course. My parents were not in the resistance; I wandered in this atmosphere that was ordinary and removed from the events of the world, which was similar for many children who were born at the beginning of the conflict. At the end of the war, I have a fairly good memory of the Liberation parade in Bordeaux, but this parade was just another form of entertainment. I have a memory of the first election, the ballots that were distributed . . . and also, immediately, of the first contact with America, because I went to the movie theater in Bordeaux with my grandfather and saw

Dumbo, the animated cartoon by Walt Disney . . . What always struck me is that the Americans were very organized and things arrived quickly—movies too, not only chocolate and chewing gum!

Afterwards, my father was assigned to the French occupation troops in Germany because he was a military engineer and had learned German in school—his own father, a man of very modest means who spoke no foreign languages and had fought in World War I, had wanted his son to learn German so that there would be no more war. So my family left for Germany. I had a sister who was born in 1942. A brother and two other sisters were born later on. I spent the next five or six years in Baden-Baden, so the true location of my childhood was there. I spent all of these years in an occupied country. I have a somewhat strange memory of empty storefronts, but I'm struck by the fact that I don't remember much of anything else. I had never been told about the war back then, or at least I have no memory of being told about it. Still I have a very precise memory of having rummaged through a huge heap of magazines and books one day that were piled up in the courtyard of a castle in Baden-Baden, and I took a special edition recounting a trip that Hitler took throughout Germany, meeting children, women, and the elderly. I also picked up a Nazi primary school reading book that was printed in Gothic script (*Fraktur*) and had several images of little boys and girls in *Hitler-Jugend* outfits, bearing swastika armbands, dancing around maypoles, and so on. I've always wondered why I picked up those books. It probably wasn't by chance, but I don't know what I was aware of exactly. I really don't know.

I returned to France in 1951 in the middle of my sixth grade year, which I'd begun in Germany in Baden-Baden in a French *lycée* that was named after Charles de Gaulle. When

I returned to France—in the Southwest, in Bergerac—I was still so unaware about the war that I continued to wear *lederhosen* because it was an extremely practical outfit that didn't rip or stain easily. But Dordogne was a place where there had been Maquis and resistance fighters, some of whom had been executed by the Germans. This explains why some of my comrades did not appreciate my *lederhosen* or the fact that I spoke German, which I probably bragged about. This led to getting into some fights. It was rather strange that people without any political awareness, like my parents, could allow the enormity of what was happening to pass by their child unnoticed. Basically, I grew up with this kind of unawareness, until little by little some things began to happen. One event in particular was the revelation of the Jews' existence, because, in my mind, I'd completely assimilated the Jews to the Hebrews whom I was learning about in catechism—Abraham, Moses, Isaiah, and so on. So one day—I was about 15 perhaps—a classmate from North Africa said to me as we were coming out of a shop where I was having stamps made for an organization: "Did you see that guy?" I replied, "What? What was there to see?" He said, "He's a Jew!" And then, in 1956, when I was 16, there was the Hungary affair. At this time, I remember seeing the flyers denouncing the Russians in Budapest, and a group of classmates in the street . . . One of my best friends at the time was Henri Nallet—he's still a friend—who went on to become the minister of agriculture and justice. His father was one of Pierre Poujade's lieutenants. I have to say that all of this was pretty foggy to me, even if the political behavior of Henri's father left a strange impression on me as something of an attitude or cause that I felt wasn't really defensible. I suspected something, particularly in the opposition to State control, to taxation, and in the refusal of financial audits. And so, for me, the world was steeped in an atmosphere that

was extremely vague and politically, morally, and ethically unclear.

Things could have remained that way if the Young Christian Students (YCS) hadn't recruited me.[3] This occurred when I met the chaplain of my lycée, Abbot Barré, a very dynamic young priest who was not an intellectual but whose training had been marked by leftist Catholicism. This took place at the public middle school Henry IV in Bergerac. So I started participating in this movement, which at first consisted of meeting to work on biblical texts. As I realized much later, this was certainly the beginning of something for me, the beginning of a relationship with texts as an inexhaustible resource of meaning or sense [*sens*]. The biggest revelation that I had through this exercise was that, in a text, there is practically an infinite reserve of sense. This kind of relationship to a text was already a specific one in a Catholic context—which is to say that Protestantism and hermeneutics had influenced it. Basically, this is what I was trained to do: One has to interpret a text and this interpretation is infinite. Of course, we weren't taught the four senses of scripture, but this was the mindset. In addition to this, throughout these years the YCS took militant action at the school and for the school. We worked in every possible way—by informing ourselves and by participating in campaigns for the democratization of education. The major issue, among others, was the question concerning the steps to reform the *collège* according to the Langevin-Wallon Plan. I participated in this type of activity for quite a long time afterwards, beginning with student unions, which in turn led me to unionization more broadly and to the internal transformation

3. The Young Christian Students was created in 1929 as part of the Catholic Social Movement.

of the CFTC[4] through a movement called "Reconstruction." The point was to reconstruct syndicalism on something other than a religious basis: that's how the CFTC became, for most of its members, the CFDT.[5]

So, for me, two paths opened at once: a path of social and political activism, which was becoming increasingly independent, and another path, a relationship to the Bible and the evangelical message, which continued to have consequences on interpreting texts, even as the adherence to religion slowly diminished. All of this played an important role. This was the initial ferment of my intellectual formation.

P.-P.J.: In the end, this ferment came from a political and religious engagement that, at this young age, you couldn't have theorized as such . . .

J.-L.N.: What happened is rather that during this time—I can't date it precisely, but it was between the last year of high school and *hypokhâgne*[6]—I became aware, as a result of an article that I'd read, that social but also intellectual advocacy (thinking and acting for democracy, for example) could be carried out without referring to religion. At that same moment, I felt that the properly religious relationship that I

4. The *Confédération Française des Travailleurs Chrétiens* (French Confederation of Christian Workers) was founded on November 1–2 in 1919.

5. The *Confédération Française Démocratique du Travail* (French Democratic Confederation of Labor) was founded in 1964.

6. [An advanced course of study in the humanities that prepares high school students for France's elite university, the *École Normale Supérieure*. The first year of study is nicknamed *hypokhâgne* and the second is called *khâgne*—Trans.]

was able to have—what could only be called a relationship based on prayer, I believe—was shaken. The parallelism between religion and politics diverged considerably because, on the one hand, what I did politically did not need a religious basis, and, on the other hand, the mere possibility of being in what I could think of as a relationship to God—addressing him, having to recognize myself as a sinner, having to confess, having to receive the communion of the body of Christ—all of this had completely lost any substance. At the same time, I have to say that another *basso continuo*[7] played on with insistence—the urge to write. I wrote a great deal of poems, which is probably just a childhood practice that's ingrained in our culture. I think more and more that there's a marked difference between writing poems and writing stories or diary entries. What really interested me was writing poems in traditional forms, the sonnet in particular.

P.-P.J.: Even as an adult, you've worked with these forms quite well. I remember this parody of "The Young Fate" [*La Jeune Parque*], which became "The Young Skate" [*La Jeune Carpe*] . . .

J.-L.N.: Yes, because when I wrote "The Young Skate" it was to go back to a habit that I'd had for a very long time, from the age of twelve to twenty-two. I moved on from the sonnet to free verse—I even tried to publish some and I was put in my place by Camille Bourniquel, who was the literary advisor for the journal *Esprit*.

P.-P.J.: You submitted your first poems to the journal *Esprit*?

7. [A bass line that is characteristic of the vocal and instrumental music of the Baroque period—Trans.]

J.-L.N.: I was put in contact with *Esprit* in my twenties because the bishops of France had just condemned the Young Christian Students because, since the beginning of the Algerian War, they'd taken positions that were judged to be too leftist—I shared their view incidentally since I worked for the YCS newspaper. This led to some tense family relationships because this wasn't how my father saw things.

P.-P.J.: 1954 is, in fact, the year the Algerian War began; it's also the year when the experiment of the worker-priest was condemned.

J.-L.N.: Yes, and in 1956 the YCS was condemned. It was an earthquake for all of the activists. The question then became whether to stay or leave. Henri Nallet, who had been my companion in the YCS throughout high school and who had subsequently become responsible for the national team, decided to stay in order to try to maintain the spirit of the movement, despite the condemnation. But as for me, I said no. So I left. This played an important role: It was an emphatic break from an institution where I had never sensed any discord, even though it could've already been there.

And this is why, because I really wanted to have my poems published, I brought them to *Esprit*. I was told politely that they needed more work. I was bitter . . . At the same time, I did some theater, I put together a small troupe. Quite a bit of literary activism preceded my entry into philosophical work.

P.-P.J.: In *Retreating the Political*,[8] you recall this double origin: *Esprit* and the CFDT . . .

8. Philippe Lacoue-Labarthe and Jean-Luc Nancy, *Retreating the Political*, ed. Simon Sparks (London: Routledge, 1997).

J.-L.N.: Exactly. I was then introduced to the people of *Esprit* by Robert Fraisse, who died not long ago. He was educated at the *École polytechnique*[9] and spent his life at the *Commissariat au Plan*[10] in a spirit of socialist-leaning progressivism inspired by Christianity. In 1963, we'd both been invited to a sort of internal colloquium at *Esprit* on the question of our generation's silence.

P.-P.J.: Hence your article, "A Certain Silence," published the same year in that journal. Other articles would follow, notably, in 1967, "Catechism of Perseverance." We should probably note here that the texts are contemporary with the Second Vatican Council.

J.-L.N.: Sure.

P.-P.J.: At that moment, like Gérard Granel, for example, you still had a discourse that was couched in faith, but one that was opposed to a certain conception of the magisterium.

J.-L.N.: At least to a certain conception of the magisterium, if not to its entire edifice. There was the question of the ecclesiastical institution as such. I often thought to myself that basically this question was never really asked because, for Granel, or for myself, I know that there's a notion of the Church as something other than an institution; the Church can also be presented as a people, a flock, a notion that is not as hollow or communitarian, as sheep-like as it might sound. I think that in general people have neglected

9. [Nancy uses the word *polytechnicien*, which refers to a student or former student of a prestigious engineering school whose graduates often secure positions in government.—Trans.]

10. [A former government institution in France that determined economic and industrial policy—Trans.]

this question because everything was covered over by the image of the Roman Catholic Church, the hierarchy, the magisterium, the dogmatic edifice, and so on. One should keep in mind that all of this was happening within a context of great intellectual and spiritual activity.

Concerning Vatican II, I think I had the feeling that it was arriving too late. John XXIII was a person who attracted sympathy, but we already knew that what Vatican II touched upon had been touched upon before as soon as the Church had had to take stock of the new things at stake in modernity. Vatican II intervened ten years after the start of the thinking it concerned itself with, and no one trusted the Church anymore to solve these problems. It was suspected that the attempt at *aggiornamento*, or reform, lagged desperately behind something that could no longer be dealt with from within the Church. The real situation at the time must have been even more complicated than the one analyzed in my article "Catechism of Perseverance."

In fact, I remember well why I chose this title. It was a phrase that had become obsolete. It was used to describe the catechism as an educational institution for those who had already received Confirmation, and thus who no longer had to learn a catechism in preparation for Confirmation. The catechism of perseverance meant that those who were confirmed continued to educate themselves in order to gain a deeper understanding of the articles of faith even though there was no longer any institutional requirement for it. With this title, I wanted to imply that beyond any institutional requirement, perhaps even beyond belonging to the Church, there remained something for which one should persevere.

There was a restlessness within Catholicism, which in France represents a great deal and basically meant the entire, extended discovery by the Catholics of all of the Protestant work of demythologization; it wasn't just a question

of the hermeneutic tradition anymore, but also an issue of interpretation that went much further and crisscrossed with philosophical paths. Because interpretation, that was Gadamer's concern, and Gadamer was one of the first and most important students of Heidegger to have placed an emphasis on the hermeneutic demand. A great number of things came together at that moment. Some Jesuits and a few Dominicans undertook an enormous effort toward the intellectual opening of the Church to philosophy—Jean-Yves Calvez with his works on Marx, Xavier Tilliette on Schelling, François Marty on Kant, and Georges Morel, who gave a course on Hegel to a circle of Catholic students, which a *khâgne*[11] classmate from *Louis-le-Grand* brought me to . . . There were all of these transformations and there were also defections from the Catholic Church; at the same time you saw the beginning of an internal reassessment within Marxism, which led to the Althusser phenomenon, himself preceded and accompanied by other signs of reassessment, for example on the concept of "alienation"—I'd been struck by the fact that the communist students' periodical, *Le Nouveau Clarté*, had devoted an issue to this question of alienation at the beginning of the '60s. There had been this entire shift through which several thinkers arrived—Althusser; Foucault, who had already entered the scene but in a less visible way; Deleuze, with his *Nietzsche*,[12] which I had read before *Difference and Repetition*;[13] Derrida, of course; and, in between the two, Lévi-Strauss, as well as Lacan (even though Lacan hadn't yet published anything at that point). But I

11. [Cf. footnote 6—Trans.]

12. Gilles Deleuze, *Nietzsche and Philosophy*, trans. Michael Hardt (New York: Columbia University Press, 2006).

13. Gilles Deleuze, *Difference and Repetition*, trans. Paul Patton (New York: Columbia University Press, 1994).

believe that if, in 1963 at *Esprit*, my generation was being interrogated about its silence, this was because people like those at *Esprit* thought they had a strong, well-established tradition that one only had to manage, a tradition that was Christian, humanistic, social, etc., and they were beginning to be a bit worried because they thought that the younger generation didn't quite adhere to this tradition and felt that it wasn't being renewed. Also, at that moment Jean-Marie Domenach wrote a book on the tragic[14] and I think that it was because he was aware of this . . . There was unrest and, at the same time, everything that the other names indicate, what was called "the thought of '68," had started to make its mark and spread. As for me, the day that I discovered Derrida's text for the first time in 1964, a text that had been published since 1962, I felt that something was bursting open. There was a timeliness to this thought, and the very language that was absent, which *Esprit* had called into question in 1963, was no longer absent. A new language was trying, at least, to find itself. This is how I entered '68, absolutely not by way of the intra-university tremors that sparked it all, the question of the sociology and psychology students, or the question of the university campuses, etc. All of these phenomena became pressing issues because of a great intellectual transformation that touched upon Marxism and the question of the representation of society and history—the question of the sense of history, the sense of struggles.

One mustn't forget that this profound upheaval of ideas took place at the same time as the Algerian War was com-

14. Jean-Marie Domenach (1922–1997), editor of *Esprit* from 1956 to 1976, published *Le Retour du tragique* in 1967 through *Éditions du Seuil*.

ing to a close, an end marked by an immense ambivalence: On the one hand, we thought that the good cause, that of decolonization, had triumphed, but, on the other hand, I have a very good memory of a general awareness that the leaders of the new Algeria were Stalinists, with a very harsh, very violent party apparatus, which by the way had already undertaken serious eliminations, internal purges, things that were not discussed publicly for a very long time[15]—even if I don't recall very well what I knew about it back then. For my part, I became aware of this during a program to train professors for the future Algeria; the project had been developed covertly and was then carried out in broad daylight. But this training program, in which I participated, was supervised by FLN representatives, and I was shocked because I had never experienced authoritarianism or ideological censorship. Because I hadn't been around the Communist Party much, I hadn't experienced this kind of situation, and I was overcome by the feeling that the entire anti-colonial struggle had wound up at this impasse.

P.-P.J.: Perhaps this is also the feeling that emerged after Bandung (April 18–24, 1955) when the hopes that this conference had given rise to were dashed. This even led some people to conclude that colonization was preferable given that we'd been unable to get rid of it democratically . . .

J.-L.N.: For me, it didn't make me think that colonization was a good thing but that decolonization was going awry. The Bandung Conference signified a great deal of things for us, the young Christian activists. I found a pile of notes a few years ago from around that time on the Quran, which I had been reading in the '50s. I'd completely forgotten that,

15. Cf. *Outside the Law* (2010), a film by Rachid Bouchareb.

as a young Christian, I had read the Quran, because I had been told: To be well educated, one must not only read the Bible but also the Quran.

P.-P.J.: Speaking of which, you've quoted the Quran in your recent works.

J.-L.N.: Yes, I reread it. But I completely forgot that I had already read it. I knew I'd read Berque, Massignon—for example, his book *The Passion of al Hallaāj*[16]—a little Corbin too . . . But I was struck in a similar way by the unpublished manuscripts of Levinas—I've been working on publishing the third volume of his writings.[17] In the texts that were written in Russian, around the 20s, next to some poems, a good number of which are even Christian, there are stories, and among them, one or two are Islamic stories, that is to say that they are written according to the model of the Oriental story with mention of the Prophet, Allah, and moralizing anecdotes . . . It's quite astounding that a Jew from Lithuania had any connection to this literary model—a bit like how *One Thousand and One Nights* could be a model for Proust. I have a rather strange feeling when I think about the presence of this Islamic reference, which was evidently a very literary and bookish one, in the absence of actual Muslim people . . .

P.-P.J.: I'm noticing something fascinating: You've introduced your journey into the world through a religious path and a "political" path, in a broad sense, yet, according to

16. Louis Massignon, *The Passion of al Hallāj: Mystic and Martyr of Islam*, trans. Herbert Mason (Princeton: Princeton University Press, 1982).

17. The first two volumes of the complete works of Levinas were published by Bernard Grasset/IMEC in 2009.

your official title, you're a professor of philosophy and we've witnessed the entry into philosophy through this Hegelian Jesuit.

J.-L.N.: I'd say that when I came upon Hegel, it was the first philosopher that was introduced to me in a lively manner. But as for philosophy itself . . . I was already studying philosophy at that time.

P.-P.J.: What may come as a surprise for someone who is familiar with your work is to discover that you were a Hegelian at first and to learn, through reading your interview with Dominique Janicaud,[18] that you came upon Heidegger—whom you often make references to later on—a bit late, a bit indirectly, even irreverently, through a pastiche!

J.-L.N.: I was introduced to Heidegger through a friend, François Warin,[19] who had studied under Beaufret in *khâgne*, and who had been in contact with François Vezin, among others. I discovered Heidegger through him and, even if he himself had never been a "Beaufretian," he came out of this environment. Besides Hegel, I knew something else; I'd had a Thomist professor to start with, in *khâgne* in Toulouse. As for Heidegger's *Letter on Humanism*,[20] it had had a comic effect on me—man as a "shepherd of Being" . . . Incidentally,

18. Dominique Janicaud, *Heidegger in France*, trans. François Raffoul and David Pettigrew (Bloomington: Indiana University Press, 2015).

19. François Warin, *Nietzsche et Bataille: la parodie à l'infini* (Paris: Presses Universitaires de France, 1994). See also François Warin, *Le Christianisme en héritage: roman, gothique, archéologie et devenir d'un contraste* (Strasbourg: Le Portique/La Phocide, 2011). This book contains a text by Jean-Luc Nancy: "Déshérence."

20. Martin Heidegger, "Letter on Humanism," trans. Frank A. Capuzzi and J. Glenn Gray, ed. David Krell, in Martin Heidegger, *Basic Writings*, ed. David Krell (New York: Harper Collins, 1993), 217–65.

even today, I think that the "shepherd of Being" is not what is needed for thinking. Something about it always runs the risk of verging on a sort of piety, a way of being in devotion. This made me want to parody Heidegger and mock Heideggerians, and I managed to trick François Warin, who truly believed that Heidegger had written a text on Auguste Comte—which is what I had chosen to write. So, that's how I first encountered Heidegger and I believe that I owe my having persevered with this author to François Warin's insistence. A little later on I discovered *Sein und Zeit*;[21] incidentally, I'm not finished with *Sein und Zeit* and I don't think anyone is. This does not mean that one should always return to it, but that it's a moment—a turning point—that's necessarily inexhaustible, it shifted the balance, in the same way that the *Critique of Pure Reason* did. When I had to study Kant, that is, when I had to study it for the *agrégation*[22]—because I had never thoroughly considered his work before—I started to take into account the enormity of the Kantian operation, which appeared greater than that of Hegel to me. Kant accounts for a considerable transformation, which had already occurred and was that of the modern sciences, and secondarily, of modern politics. The point of departure is that of the sciences and the question of sensibility. And to come up with pure, *a priori* sensibility, that's really something.

P.-P.J.: *A priori* sensibility, this seems like a monstrous contradiction, an oxymoron at the very least.

21. Martin Heidegger, *Being and Time*, 1927, trans. John Macquarrie and Edward Robinson (New York: Harper and Row, 1962).
22. [A competitive examination that certifies teachers and professors for work in the public education system—Trans.]

J.-L.N.: I think the tension that's created in Kant by this oxymoron also generates the greatest difficulties, the difficulty of the definition of the schema or the problem that Juan Manuel Garrido tackled,[23] the question of the *a priori* formation of the forms.

But these difficulties are worth the trouble because, thanks to them a new path or new life of philosophy begins with Kant. The systems of the representation of the world found themselves called into question, long before Heidegger said that the era of the "conceptions of the world" had come to an end; even though new possibilities of representations of the world are put forth with Fichte, Schelling, and Hegel, from then on something prevents a representation of the world from being constituted and analyzed in the same way as in Descartes, Malebranche, Spinoza, Leibniz, Hobbes, Locke, and so on. What changes with Kant—what he himself says, basically—is that pure reason is practical, that pure reason in its theoretical use can no longer have an object, so that representations are dismissed or at least can't have the same status as they did before. By contrast, pure reason is in itself practical, which is why it doesn't need a critique, but rather a critique of its use. What Kant taught us is that, in its simplest formulation, pure reason is practical in itself. I find this lesson lively and dynamic because it means that in our desire for the unconditioned, in our desire for sense, we're practical, we act in the world, and so, *a priori* sensibility, one could say, is *praxis*. In every case, I am in action. This action relates to ends that cannot be grasped by a determinable idea such as freedom; in this sense, I would say that Kant

23. Juan Manuel Garrido, *La Formation des formes* (Paris: Galilée, 2008).

makes Kierkegaard, Marx, and Nietzsche possible. From then on, philosophy wants to be an account or act [*acte*] and transformation of the world. This doesn't mean that the idea of a self-realizing philosophy is anything more than illusory, but that's another matter.

To go back to Hegel, I think Georges Morel introduced me to Hegel as an author whose thought, and whose language to express this thought, were engaged in practical, sensible action. In the end, I didn't see Hegel as a philosopher who drew a large fresco on a wall in order to look at it, but rather as a thought that engages itself at the cost of extremely difficult, complicated work and linguistic effort at the limit of intelligibility. I found something in it that in any case I couldn't really see in Kant—this extraordinary desire to capture everything, to name everything, to predicate everything in order to be able to suppress all predication in the speculative. This absolutely thrilled me. The idea of eliminating the opposition of the subject and the predicate in what Hegel calls the speculative proposition was completely fascinating to me.

P.-P.J.: Isn't it also about measuring oneself against this inaugural gesture of separation, be it in Kant or in your own work, between the sensible and the intelligible? Because if one goes back to the example of Kant, one does notice the surprising silence between the *Letter to Marcus Herz* (1772) and the publication of the *Critique of Pure Reason* (1781), a letter in which he pointed out that basically there was one thing that had never been thought by metaphysics: the relationship between the sensible and the intelligible.

J.-L.N.: I had the feeling that Hegel was the first to go as far as possible to make the intelligible sensible, through the dialectical movement that in fact animates it.

P.-P.J.: "Sensible" is a rich word and it makes me think of the first program of German idealism: that reason must become sensible and sensibility rational. But I heard you saying that, today, we can't continue on with this distinction, from which we are still unable to detach ourselves, between emotion and thought.

J.-L.N.: At the same time, one mustn't confuse the two. On the side of emotion and the sensible, there is something that's necessarily of the order of the obscure; and yet we are, as philosophers, a group of people who want clarity. We want clarity within obscurity, or even obscurity as clarity. In Bataille, we find the sentence: "I look into the night and enter it"; but no philosopher truly takes it upon themself to do that because philosophers are supposed to introduce light into the world. And even for Bataille, it's still a philosopher's gesture, because he wants to look; he doesn't accept letting himself go into the lack of visibility. The philosophical act can only be sustained if it's oriented, perhaps hopelessly, towards a hypothetical visibility. At the same time, I think that the motif of visibility, bringing to light, representation, or form has been continuously accompanied through the succession of Platonism, Cartesianism—even if none of these "-isms" are really faithful to the proper names from which they are derived—by a degradation of the sensible. I was a child of my time, too; Bataille himself was shaped by the introduction of Hegel in France by Kojève; along with these two, one mustn't forget the shaping of the sensibility of the French in the '20s, notably by Bergson, who, through his works, drew attention to registers that aren't only of the order of rationality. This is why I was particularly receptive [*sensible*] to Derrida; I would have been more so to Deleuze, but the texts of Deleuze that I would have been receptive to are the ones

that came after *A Thousand Plateaus*.[24] When I read *Voice and Phenomenon*,[25] it is precisely the extraordinarily sensible character of the "wink" [*clin d'œil*] that touched me, when Husserl says that the silent voice refers back to itself in a wink and when Derrida exclaims, "Yes, but the wink has a duration, its own duration!" This implies that the metaphor of the wink loses, all of a sudden, its metaphoric character—it becomes a gesture. Reading this, I had the sensation of what I was reading in the book—the wink—and I said to myself: "Oh my God, it's true!"—there is no pure and simple presence to oneself, there is no purity of Being to itself or in itself, there is no propriety. So, I believe it is a sensibility that touched me. All of the great philosophers are people who have a sensibility; Bergson is sensitive to flux and duration, Derrida is more sensitive to the instant, its tension, and its gap or spacing [*écart*]. One could say that temporality, approached in diverse ways, is a question at the heart of modernity.

P.-P.J.: But isn't it the case that this sensibility is very different from what one expects of a certain philosophy, the elaboration of a knowledge that gives stability?

J.-L.N.: That's true. And I was just about to speak about the relationship of sensibility to signification, to representation today. The capacities of discourse to signify the sensible, far from solving everything—even if before us there was a succession of operations of philosophical transformation

24. Gilles Deleuze and Félix Guattari, *A Thousand Plateaus: Capitalism and Schizophrenia*, trans. Brian Massumi (Minneapolis: University of Minnesota Press, 1987).

25. Jacques Derrida, *Voice and Phenomenon: Introduction to the Problem of the Sign in Husserl's Phenomenology*, trans. Leonard Lawlord (Evanston: Northwestern University Press, 2011).

going in this direction [*sens*]—to me allow for a shortfall of sensibility to persist. I always have the sense in my own work, in my own writing of texts, that I'm too violently propelled onto the side of the concept, that is, onto the side of a discourse that has no grasp on the real. One could say that I begin speaking the language of the enemy or all of the people who accuse us of not sinking our teeth into the real . . .

P.-P.J.: But in this case, when one reproaches philosophers for not "sinking their teeth into the real," what's the status of this "real"?

J.-L.N.: Yes, of course. To sink one's teeth into what, and what is it to sink one's teeth into something, and with which teeth do we sink into it . . . And yet, as time goes on, I envy the writer, the painter, the musician, or the dancer more and more because I have the feeling that these people manage to do things that don't just sink their teeth into the real, but, in effect, do things which are of the real! As for myself, I have the feeling that my philosophical texts aren't philosophical enough—that they need to be more philosophical, but in order to be so, they need to no longer be philosophical, but something else.

P.-P.J.: When you read certain authors from the movement to which you belong (Derrida, Blanchot, Bataille, and Levinas among others), you sometimes get the impression that you're dealing with a language that itself crystallizes the entire significance of the text, precisely because you cannot understand it with transparency. The obscure or the resistant occupies a sort of central position. Is this what's in question in what you call the "excription," this desire that writing has to touch what evades all inscription?

J.-L.N.: I speak about my own texts in exactly this way, with the feeling that "it is not enough." I'd prefer to be able

to launch into a story, a poem. I'm never as happy as when I receive feedback from readers who are sensitive to the way that the text is written rather than to the analytical, argumentative, demonstrative, and intellectual understanding of what I wrote—even though this aspect is important. I'm much more touched if people tell me, "I didn't understand everything, but it had an effect on me."

P.-P.J.: I would be tempted to call this sensitive thought. Of course, this adjective is very loaded; I was implying a thought that touches, and not a thought that shows.

J.-L.N.: Sure, if you like. In the end, thought has its greatest strength there. Always. Even with the rationalists, whether they be Descartes or Leibniz, there's a sensibility that's being expressed, for example, in the role of "passivity."

P.-P.J.: It's true that, in French, the words *passif* and *passivité*, whether we would like it or not, are in fact too "passive" upon first hearing them. Whereas here we're probably closer to the notion of receptivity. But with "receptivity," we fall back into the "monstrosity" that Kant was confronted with, that is, understanding as a spontaneous receptivity (spontaneity as an act and, at the same time, receptivity as "passivity").

J.-L.N.: Of course. In a certain way. Spontaneous receptivity or receptive spontaneity—one can't say it any better. Afterwards, indeed, one has to elaborate, but it's not such a bad thing to be able to think that by itself, *sua sponte*, a thing or a being—I don't know how else to say it—receives. The living, isn't that what it is first? The living, by itself, is able to receive. Not only in the sense that a stone receives a drop of water, but also in the sense that blades of grass are able to receive sunlight and accomplish photosynthesis, and so on.

To receive isn't to be subjected to: To put it in the language of Aristotle, "passivity" is a "power" (*dunamis*) too.

P.-P.J.: This way of articulating activity and passivity has consequences for the concept of thinking about the relationship between the subject and the object. In *Adoration*,[26] you distance yourself from phenomenology, that is, a distinction between the subject and the phenomenon that implies a "vis-à-vis" attitude. So, the world is no longer a "vis-à-vis" but that to which one addresses oneself, adoration as an address is the adoration of nothing and not the aim of an object. This is one of the most important passages in the work. How can one relate to the world today if the world is no longer a describable, calculable, and predictable object? How does it come to us?

J.-L.N.: One could say that the world isn't an object at all anymore. And doesn't this increasing sensitization of philosophy—perhaps it's merely a resensitization after the entirety of rationalism made us believe that we could float above the sensible while despising it and only dipping our toes in it from time to time—consist in recovering the world? Recovering the world, which also means to be in the world. The world as an object; Descartes gives the most striking example of this when he writes his *The World* or *Treatise on Light* [*Traité du monde et de la lumière*].[27] But this world, which has become an object of knowledge, and of exploration and mastery, is at the same time a world where human beings' presence—and perhaps this can be extended to the

26. Jean-Luc Nancy, *Adoration: The Deconstruction of Christianity II*, trans. John McKeane (New York: Fordham University Press, 2013).

27. René Descartes, *The World and Other Writings*, trans. Stephen Gaukroger (New York: Cambridge University Press, 1998).

presence of living beings in general—has been pushed aside. In fact, human beings no longer live in the world in the sense of Hölderlin, reprised by Heidegger, when he writes: "poetically, man dwells."[28] "To dwell" [habiter] means to be in the habitus, not in the habit but in the "disposition," an active disposition. In the end, habitus is not far from ethos; what we need is an ethics of the world. This is perhaps the greatest issue of Western civilization, which has now become worldwide [mondiale], or global [globale]—to have had this will to transform the world in order to make it a human world, although it's possible that we've left this world behind. Or that, eventually, we will find ourselves in a group of elements, data, matters, apparatuses, and networks within which we feel captive and from which we have become alienated, because this world that we've mastered escapes us. It escapes us precisely as world. Images of the world must be substituted for a dwelling [habitation], a life of the world, in the world. This is what Heidegger meant when he introduced what we translate as "Being-in-the-world" (in-der-Welt-sein); to say that the existent, the Dasein, is essentially in the world simply means that it's necessarily involved in the circulation of meaning or sense, which is what makes a world. Heidegger himself defines the world as a totality of significance. The world is a possibility of sense or meaning's circulation and we have to make a world, to remake a world.

P.-P.J.: In fact, this is what I really appreciate about the end of your preface to the Italian edition of your work *Categori-*

28. Friedrich Hölderlin, "In lovely blueness . . ." in *Friedrich Hölderlin: Poems and Fragments*, trans. Michael Hamburger (London: Anvil Press Poetry, 2004), 789.

cal Imperative:[29] The imperative is what has been given to human beings in order to make a world.

J.-L.N.: Yes, I believe that it's truly one of the senses that can be attributed to the Kantian imperative. "Act as if the maxim of your action were to become a universal law of nature"—in the end, this means that what's at stake is to make or remake a world.[30]

29. ". . . the subject as subjected to the receptivity of that command (. . .) receives the command—it receives itself as command—of making a world. However, it is not a question (and this is what the subject must understand) of coming to occupy the place of the demiurgic being, as it is precisely that place that has just been emptied. It is a matter of standing in this void and remaining within it—that is to say, to re-engage anew what 'ex nihilo' means." Jean-Luc Nancy, "From the Imperative to Law," trans. François Raffoul, in *Jean-Luc Nancy: Justice, Legality and World*, ed. B. C. Hutchins (New York: Continuum, 2012), 11–18.

30. Immanuel Kant, *Groundwork of the Metaphysics of Morals*, trans. Mary Gregor (New York: Cambridge University Press, 1997), 31. [Nancy is paraphrasing this passage orally—Trans].

The World

P.-P.J.: It seems completely natural, then, that we ask ourselves now about the "possibility of a world," first by taking into account what you say in *Corpus*. Our world is no longer simply a *cosmos*, a *mundus, partes extra partes* (an extension of distinct places), but the world of the human crowd, the non-place of a proliferating population, "[an] endless, generalized, *departure*."[1] I'd like to ask you, then, about the role you give to the idea of the numerous or plurality within your entire approach, whether it concerns politics, the thought of community, or, in another register, the plurality of the arts.

J.-L.N.: I completely agree with your suggested point of departure: the world as the place of numerousness or the

1. Jean-Luc Nancy, *Corpus*, trans. Richard A. Rand (New York: Fordham University Press, 2008).

multiple. We no longer live in a *cosmos* in the Greek sense of the word—that is, we no longer perceive the totality of an ordered and thus beautiful world—a double signification to which the words "cosmonaut" and "cosmetics" bear witness. Today it's no longer possible to speak of a beautiful, cosmic order because altogether the galaxies do not really present an order—physicists describe a finite world in an infinite expansion. It's no longer possible to describe an order that would be comparable to that of the Ancients, who represented this order as spheres containing one another. As for the world around us, even though we still speak of a distinction between mineral, vegetable, and animal kingdoms and still find a hierarchy in this classification, we can no longer say that this hierarchy is oriented toward a certain end or whether this end is humankind as Kant thought. Indeed Kant thought that human beings were the end of nature because they are the Being of ends. It is rather the case that we are beings that constantly assign new ends for ourselves, and do not—or do not only—do this infinitely but rather in an undefined way, and thus we no longer know for which ends we should really aim.

P.-P.J.: In order to explore this question of the end further, we might return to the series formed by your works from *The Sense of the World* and *The Creation of the World* or *Globalization* to the chapter "Of Struction" in one of your last books, *What's These Worlds Coming To?*[2] Incidentally, it's

2. Jean-Luc Nancy, *The Sense of the World*, trans. Jeffrey Librett (Minneapolis: University of Minnesota Press, 1997); Jean-Luc Nancy, *The Creation of the World* or *Globalization*, trans. François Raffoul and David Pettigrew (Albany: State University of New York Press, 2007); Aurélien Barrau, Jean-Luc Nancy, *What's These World Coming To?* trans. Travis Holloway and Flor Méchain (New York: Fordham University Press, 2015).

not by chance that you wrote this book with a young astrophysicist, Aurélien Barrau.

J.-L.N.: Absolutely. It must be noted that this astrophysicist is also a philosopher. He's very attached, and rightly so, to both titles. I learned a lot from him concerning the fact that today astrophysics is compelled in a way to think a plurality of worlds, which has a twofold effect. On the one hand, for scientific reasons that only physicists can expound upon accurately, one must think a plurality of worlds, what they call a "pluriverse" or a "multiverse." One cannot retain the model of a single universe. In the end, if one admits that the expression "a single universe" is a pleonasm because a uni-verse is directed toward unity, then we even have to give up on the thought that we're in a universe that can be conceived of as a version of the One.

The second effect is just as important: From now on all theories of physics have to think of themselves as a construction of fictions. Without these fictions, one cannot think that in which one is, but even with their help, one is still unable to say that one thinks an object, or a real to which one would be coming increasingly closer. Currently, but in a way that still isn't very apparent, we're getting further away from the scientific model that uses mathematics as an instrument to grasp the real—a model that we've had since Descartes, the first to have really conceptualized it as such, but which was already present in Galileo and Kepler. Basically, up until the time of Einstein more or less, we considered mathematics to be a privileged instrument for approaching reality, and the idea that Einstein's formula, $E = mc^2$, is the formula of the universe is still widespread. In fact, today we know that several theories seem incompatible with one another, like Einsteinian relativity and quantum theory, and the emergence of increasingly more numerous

and diverse theories shows us that the objects of observation and measure for contemporary science are entirely fabricated by the scientific operation itself—in a certain way, we philosophers, brought up in epistemology since Bachelard, knew this for a long time already . . .

In *The New Scientific Spirit*, Bachelard writes, in effect, that "[I]nstruments are nothing but theories materialized. The phenomena they produce bear the stamp of theory throughout."[3] So today we have at our disposal a new, very powerful particle collider.[4] But even with these means, or indeed along with them, it's absolutely impossible to say that one is observing a reality that could be there, somewhere, at the end of ends. On the contrary, we produce, we multiply new objects according to several approaches, and thus we manage to produce several worlds. It's better to say, perhaps, in order to avoid harming the spontaneous, realistic feeling, that we produce several possibilities of worlds or even several fictions of worlds. Nevertheless, even this word, fiction, is dangerous because it could allow one to think that behind this fictional world lies the true world, when we are perhaps moving past the representation of science as an objective knowledge that comes closer to a real that exists in itself. A displacement of this kind can even resemble—but it's simply a question of resemblance— what one imagines to be the world of those who live in myths. These beings don't represent for themselves a real in itself whereby myth speaks the truth; they are in a world where there are diverse presences, diverse forces that are at work.

3. Gaston Bachelard, *The New Scientific Spirit*, trans. Arthur Goldhammer (Boston: Beacon Press, 1984), 13.
4. The most powerful collider at CERN is the Large Hadron Collider (LHC), which was put into operation on September 10, 2008.

P.-P.J.: In a recent issue of *La Recherche*, Aurélien Barrau writes: "Because no model is eternal, is it not ontologically sensible to consider them as being simultaneously correct?"[5] It would then be a question of reviewing one of the founding acts of the philosophical, and thus ontological, discourse, because philosophy initially defined itself as the quest for the true as opposed to the mythical, that is, the fictitious and false.

J.-L.N.: You are referring to something that matters very much to me and is over my head at the same time. As you mentioned, here one touches the limit of philosophy. The question that gets raised, then, is knowing what one ventures into if one goes beyond philosophy. It's in this sense that one has been able to speak of "the end of philosophy": When Heidegger proposed this phrase, he was actually referring to the "end of the idea of theoretical constructions that aim at being representations of the world or pictures of the world."[6] The text that Heidegger devotes to this question is entitled "The Age of the World Picture."[7] If one understands philosophy in this sense, I believe, in fact, that Heidegger is correct in saying that we are at its end.

As far as I'm concerned, I don't use the expression "the end of philosophy" anymore because no one wants to hear it. A general resistance to Heidegger is expressed on the one hand, and to a certain way of thinking the "end" on the other.

5. *La Recherche* 446, July–August 2012, 80.
6. [Nancy appears to be paraphrasing or quoting from memory.—Trans.]
7. This is how *Weltbilder* was translated into French; it signifies "pictures of the world." Cf. Martin Heidegger, "The Age of the World Picture," in *The Question Concerning Technology and Other Essays*, ed. and trans. William Lovitt (New York: Harper & Row, 1977), 115–54.

P.-P.J.: On this point, one could recall what Jacques Derrida says, which is that the end of philosophy or the end of metaphysics is present from the beginning. This end doesn't represent a diachronic cut or happen at a particular moment; this end has always been there, precisely as an account that contains the limit.

J.-L.N.: I do think that he must have spoken of a longitudinal and not a transversal cut in the history of philosophy, which is to say that the account with myth or the rejection of myth by philosophy has a founding effect. It's a question of declaring that the *mythos*, the history told about the world, the gods, and human beings, is a lie, which at the same time implies that it's possible to produce the truth in whose name this exclusion is pronounced and, in doing so, to trace a limit. Yet philosophy, in fact, has never been able to produce "the" truth as opposed to the lie. In the end, science appeared as what would present the truth that philosophy had promised. The contemporary evolution still seems to go backwards with this expectation, which fundamentally has only ever been the very poorly informed opinion of these good people who Flaubert mocks through the character of Monsieur Homais, who thought that this expectation could be fulfilled someday. I recall that my father, who was a chemist, didn't understand that unlike the physicist or the chemist in their respective domains, the philosopher was not able to demonstrate something true about the subject of the totality of the world or God. He was a scientist brought into the bosom of the Church by Jesuits when he was a student, and so he believed in God. One day, after I had already been aggregated in philosophy, he asked me: "So, can't you philosophers prove the existence of God?" I answered him: "No, not at all, on the contrary! We have demonstrated that

we cannot have any evidence of God's existence." And he retorted: "But then it's disastrous, it's completely useless!"

P.-P.J.: I'll play off this family anecdote, which goes well beyond a singular experience, by referring again to the word "myth." One can translate this word with the word "story" [*histoire*] precisely in the sense when one says that someone is "making up a story," that is, fictions, things that are not true or real. And yet, without wishing to reopen heated debates that took place at the end of the nineteenth century and later on the historical criticism of biblical texts, among these "stories" [*histoires*], there's one that's considered "sacred." So it's a story that has a particular status, which relates to the event of Revelation. The last book that Shestov published in 1938, *Athens and Jerusalem*,[8] raises a question about this point for me. Certainly this isn't the first author to ponder this twofold legacy—the title of his work is itself borrowed from Tertullian. But what concerns me here is his very polemical approach toward medieval philosophers in a chapter that relies on the 1932 book of Étienne Gilson, *The Spirit of Mediaeval Philosophy*.[9] Basically, according to him, all medieval philosophers fell down before the word of the Old Testament and all tried, in a more or less nuanced way, to superimpose revealed truth onto demonstrated truth. And just as Aristotle estimated that the poets lied a lot, *polla pseudontai*, so medieval philosophers are not far from saying that the Scriptures make up a lot of stories. Spinoza himself said that the object of philosophy is truth whereas the object of religion is salvation and submission . . .

8. Lev Shestov, *Athens and Jerusalem*, trans. Bernard Martin (Athens: Ohio University Press, 1966).

9. Étienne Gilson, *The Spirit of Mediaeval Philosophy*, trans. A. H. C. Downes (Notre Dame: University of Notre Dame Press, 1991).

J.-L.N.: This is a set of complex questions because it may well be that there's a program that imposes itself that's neither one of demonstrable truth nor authority. What's troubling, in effect, are Shestov's remarks about medieval philosophers; this shows quite well that philosophy by itself took the path of demonstration, which was the only path that one could follow in the end if one takes the stories to be false from the start. Then one must demonstrate, that is, one must suppress the question of the primary validity of the statement, or of the enunciation even: What guarantees that whoever tells a story tells the truth? As soon as one raises this question, one becomes suspicious of everyone.

P.-P.J.: Yes, or one conflates the question of truth with the question of the truthful.

J.-L.N.: . . . and the question of the verifiable. Demonstration implies, in effect, the verification of verifiability. It must be verifiable or, as Popper says, it must be falsifiable. If one can demonstrate that something isn't necessarily true, one doesn't yet grasp the truth. In relation to this, I think that since the Middle Ages, two developments in completely opposite directions have taken place. On the one hand, modern science became autonomous and in effect completely took charge of demonstration and verification, but by way of a mathematical reduction. This is entirely the case with the process of Galileo's rupture from Aristotle on the paradigmatic question of the motion of falling bodies.[10] Correlatively, philosophy itself felt compelled to return to the

10. For Aristotle, bodies fall because of a desire to reach the center of the earth. Galileo gives up on any explanation of this kind and decides to measure the space and time of the fall. What is at stake is the thought of space and movement, of "nature" and its knowledge, "physics" (the Latin *natura* is used to translate the Greek *physis*). From

whole of demonstration, verification, etc. Then it had to renounce this since mathematics became at once the model, the ideal, and what had to be accounted for. This is basically the Kantian operation.

Between Newton and Kant, a science that functions was put into place, a sort of great architecture of the physical world that seems to be established, but whose status has not been thought out clearly because it is neither philosophical nor theological. Kant presents it as a knowledge, which he calls understanding, but as a result—and this was very important in philosophy—all of the other knowledges actually involve the question of faith and revelation. Still, and this is fascinating, the idea of revelation is given by way of something that also pertains to myth: There is the entire biblical story, then the renewal by the new story, that of Christ, etc. Let us note, however, that the content of this revelation isn't the same as that of myths at all. For the first time, the story doesn't let itself be reduced entirely to the story of this or that well-characterized person, such as Zeus or Osiris, to whom one can attribute qualities and a name. Without going into the question of the name—or absence of a name—of God and/or Jesus (Christ) right now, let us recall the division that occurs in philosophy between positing the knowledge of an object and acknowledging that the concern of desire is different; one could desire or love what one cannot know. Kant speaks well, in effect, about "desire," which in German he calls *Trieb*—the same word that Freud would use later to speak about "drive."

So this essential idea appears, according to which there is a push, a desire that is as much one of life as it is one of

Aristotle to Galileo, we go from a qualitative physics to a quantitative, mathematicalized physics.

thought, as well as one of knowledge just as it is one of pleasure. There's a sort of—I'm not sure how to say it—fundamental dynamic that's probably what concerns us most often, even though all of our habits of thought have made us lose sight of it.

P.-P.J.: One could borrow several names from tradition for this desire: *ormē*, *impetus*, *conatus*, or urge, for example. This desire is turned toward a truth that is not verifiable but that presents itself or unveils itself.

J.-L.N.: Yes, that reveals itself even, because this word is not necessarily religious, but can serve to designate an unveiling, which, at the same time, keeps its own foundation veiled. So the beauty of a work, or the impetus of love, or being touched in friendship remain "without reason," in the words of Angelus Silesius and Heidegger, yet without mystical effusion.

P.-P.J.: One should add that this tension carries us beyond any limited unity. The plurality of worlds about which Fontenelle spoke can still be thought about as a multiplication of our world.[11] When you reemploy this expression as the subtitle of a chapter of your book *The Muses*, where you demonstrate, to put it succinctly, that the multiplicity of the "arts" can't be subsumed under the unity of a concept of "Art," you insist on the irreducibility of plurality.[12] It's the world itself that's plural, and plurality or space is, so to speak, what makes it shatter from the inside.

11. M. de Fontenelle (Bernard Le Bovier), *Conversations on the Plurality of Worlds*, trans. H. A. Hargreaves (Berkeley: University of California Press, 1990).

12. Jean-Luc Nancy, *The Muses*, trans. Peggy Kamuf (Stanford: Stanford University Press, 1997).

J.-L.N.: Yes, but it's rather a question of space and spacing. Even though the hypothesis of shattering in the sense of a nuclear catastrophe, as fantastic as it may seem, isn't only unacceptable. In any case, it has inspired a number of texts or scenarios for at least thirty years—for example, Cormac McCarthy's most recent novel, *The Road*, which was made into a film.[13] That we cannot avoid this kind of projection demonstrates that we no longer feel that we're in a world. The macrocosmos of space probes and the microcosmos of nanotechnologies are no longer—if they ever were, even in Pascal—infinite variations on the same scale. There's no longer a *cosmos*, there's no longer a *mundus*, the Latin word that meant "pure."

P.-P.J.: We've already mentioned the sense of "beauty" that's attached to the Greek *cosmos*. The French "monde" still keeps this double meaning of order and "cleanliness," even elegance. One prunes [*émonde*] trees to give them a shape and beauty. And one refrains from the "un-clean" [*l'im-monde*].

J.-L.N.: So we're no longer in unity, purity, or beauty: Everything has taken on an adventurous, complex, and scattered aspect.

P.-P.J.: Let's go back to your book *Corpus* in which you distinguish between three stages: after *cosmos/mundus*, and after *partes extra partes* with its scientific explorers and conquistadors, we're in the world, *mundus corpus*, in the world of pressing bodies. I suggest we understand "pressing" in its two senses: on the one hand, as hurry, haste, crowds in all kinds of movements, migrations, as if human beings were

13. Cormac McCarthy, *The Road* (New York: Random House, 2006), made into a film with the same name by John Hillcoat in 2009.

all placeless . . . and homeless, and, on the other hand, as pressure, contact, contagion, all the modalities of the *cum*. Of course, there appears on the horizon a question about the plural of this particular *cum*, which is the *cum* of com-munity. Can we retain this expression "the pressed world," if it's also the world of an infinite spacing, a limitless "spaciousness"? We encounter a big question here, which you, following Heidegger, have already outlined: Must we pass from a thought that privileged time and hence presence as present to a reflection that would emphasize space or spacing?

J.-L.N.: Yes, and then one must understand "presence" in the sense of "being next to." It's curious that it was the grammarians of Latin rather than the Latin grammarians who noticed that the prefix *prae* doesn't have exactly the same sense in *praesentia* and *praesum*. In the latter, *prae* signifies "in front of, ahead," hence the sense of *praesum*, to direct, to command, whereas in *praesentia*, one comprehends "being next to," "being close to."

P.-P.J.: What's more, one can certainly understand "being in front of" in the sense of commanding, but one can also say: "I am in front of you." But there is also this ambiguity of the "in front of": "I present myself to you," "I am ahead of you," "I am exposing myself to you."

J.-L.N.: I agree entirely—even if this isn't the ordinary sense of *praesum*. This is in any case what guided my choice of the word co-appearance or "compearance" [*comparution*]: One compears in front of, as one compears before a judge, and at the same time one compears with.[14] In our world, it's

14. Jean-Christophe Bailly and Jean-Luc Nancy, *La Comparution* (Paris: Christian Bourgois, 1991).

multiplicity, the press that compears. It's a theme I insist on in my book *After Fukushima: The Equivalence of Catastrophes*.[15] This work responds to a question about the meaning of what happened in Fukushima. To begin with, it's, of course, about the entire question of the nuclear industry. But on the other hand, what happened in Fukushima shows that the quantitative aspect of the event is potentially transmitted to the entire planet. This proves that today almost nothing happens in the world, in our world, without the mark of quantity, tending towards the infinite. One is immediately in the world of great quantities, starting with that of humanity (seven billion human beings as of October 31, 2011). Each time one talks about things that are important for humanity, one has to refer to enormous quantities that are very difficult to grasp. As for me, when I hear "seven billion inhabitants on earth," I can't picture anything. Each time I'm in a crowd, in Strasbourg, at the *gare du Nord* in Paris, or in the Roissy airport, for example, I wonder: "What's within my range? How many are there?" And I live in a country of sixty-five million inhabitants . . . How many Chinese people are there? When I think about China, I can't picture anything, anything at all. It's the same if I think about the populations of India or Africa . . .

P.-P.J.: As one commonly says in French, "I can't picture it," "I can't imagine it"; but one can ask a more acute question on the basis of this fact that would accentuate the ontological reach of these remarks. You know what I'm referencing very well because it's an old question for you. As

15. Jean-Luc Nancy, *After Fukushima: The Equivalence of Catastrophes*, trans. Charlotte Mandell (New York: Fordham University Press, 2015).

you recount in *La Communauté affrontée*, in 1983 Jean-Christophe Bailly offered a theme to reflect upon for an upcoming issue of the journal *Aléa*: "Community, Number." In this "perfect ellipsis," as you put it, with its two focal points, the quantitative and community, you perceive the problem that is encroaching upon us with a growing urgency: Do we have at our disposal the necessary categories to think "this"?

J.-L.N.: Actually, I don't believe we do.

P.-P.J.: One should look at this question through the lens of your book *Being Singular Plural*, which was published in 1996.[16] You call for a new ontology, although you clarify that this book is not an ontological treatise, because in an ontological treatise it's Being or the Subject that speaks, which always implies the effacement of the singular. What you set up is this pair of notions—singular plural—instead of the one and the multiple or the universal and the particular, which have continuously structured Western thought.

J.-L.N.: Jean-Christophe Bailly had illustrated, so to speak, the ontological status of all these remarks on number in choosing for the journal *Aléa* the photograph of a crowd on the beach in Coney Island that Weegee took in 1938. This feeling of great number—Jean-Christophe drew attention to it by contrasting it with community. This feeling first disturbs something about our habit of thinking in terms of unity [*unité*]. In fact, the idea of community always comprehends an inner unity that all the members of the community

16. Jean-Luc Nancy, *Being Singular Plural*, trans. Robert D. Richardson and Anne E. O'Byrne (Stanford: Stanford University, 2000).

refer back to.[17] Be it religious, national, familial, or local like it is in a village . . .

P.-P.J.: . . . the town or *commune* . . .

J.-L.N.: But the *commune* is a notion that's taken from what was initially an institution, the *commune* of the Middle Ages: the parish and city commune, the urban, civic community that manages itself and sees itself as its own unit. Number, on the contrary, doesn't envision its own unity because, in a way, it doesn't have any. In the end, what lacks unity? The world, as it has already been said, but also humanity. When one speaks about "humanity" today, one doesn't know any more what unity one is speaking about. Kant maintained that one cannot answer the question "what is the human being?" the fourth question[18] that we encounter, precisely because the human being is the one who makes, transforms, and produces itself and thus in the end does more than merely reproduce. One could also ask oneself, as a first venture into ontology, whether the human being is trying to produce another being besides the human animal that we have known up until now.

P.-P.J.: You went on to write, in an interpretation of the Kantian categorical imperative, that "the human being is demanded of the human being."

J.-L.N.: This means from this moment on what is demanded of the human being, at least from the beginning of modern times, is to create a world out of nothing, *ex nihilo*. This implies that a world cannot be made out of the human

17. [The French word *unité* means both unit and unity.—Trans.]
18. The first three questions, formulated by Kant first in the *Critique of Pure Reason*, and then in his *Logic*, are: What can I know? What ought I to do? What may I hope?

being in itself. When one says "to make a human world," one doesn't really know what that conveys.

P.-P.J.: We've discussed the world about which the first Greek thinkers, the cosmologists, spoke; but one also uses the word "world" when one says that a human being "came into the world" or when looking at a large gathering: "the whole world is here."[19] In order to think about what happens, then, can one hold on to the idea of human form or figure, for example, in the sense in which one says about someone, "you're in bad shape" or "you're sick as a dog" [*il n'avait plus figure humaine*]?

J.-L.N.: Today we continue to speak about a "human" figure, whether it's related to an individual or to humanity, although we've struggled continuously for half a century with a refutation of this assertion. Let's consider what we call "humanitarian organizations" and the sense of this "humanitarian" classification: with this classification, we imply all that must be taken care of with a sufficient, benevolent, and helpful attentiveness, as well as the vital needs of people and the world, outside of any political and aesthetic considerations. From an affective point of view, the humanitarian could almost be translated as the compassionate; and from the most pragmatic, tangible point of view, a concern for the most basic aid. It's a question of survival. Yet survival [*survie*] is not life [*vie*], which is more than survival, unless one understands "survival" in the sense Derrida gives to it, as "more than life." In life, there is a kind of thriving—let's not be worried about being ludicrous—a kind of breathing beyond the need to eat, to not freeze to death, to be sheltered

19. [The French word *monde* may mean "world" or "people," and it is a common translation for the Greek word *cosmos*.—Trans.]

from bombs . . . So one can say that the invention of the "humanitarian" sector is one of the major signs of the fact that humanity no longer recognizes itself as an essence, which is defined by the quality of being particular—that humanity sees itself only as protecting its survival. As a result, humanity doesn't even know how it would be the end of nature, let alone manage to think of itself as the image of God.

P.-P.J.: It's hard, then, not to bring up the famous passage in Genesis where it's written that man was created "in the image after (*ki*) the likeness" of God, while God is incapable of being figured.[20]

J.-L.N.: But doesn't this mean that our current condition is marked by the loss of what we believed could be conquered, like the human figure, and which manifested itself in what was baptized "humanism"? This thought used to consider that man was in fact his own essence, his own "Idea," his form (this is the meaning of *idea*) or figure. This figure was perhaps secretly derived from the figure of God, when humanism used to deceive itself concerning its Christian origin. It thus retrieved all the attributes of the divine, in an operation that resembles the one that was laid out in full by Feuerbach, such as the integral transport of the divine properties in man. This author said very little: One only has to give all the qualities back to man that were attributed to God. However, and this is exactly where the problem lies, because man would have all goodness and righteousness, whereas he seems to approach omnipotence, which is also the power to destroy oneself. What remains is that the man of humanism may have believed that he was able to do with-

20. [In what follows, we leave the term "man" and use the pronoun "he" for philosophical and biblical context.—Trans.]

out the figure of an all-powerful God, while considering that he would still have the capacity to envision what Kant calls a humanity "living under moral laws." Without a doubt, for the philosopher from Königsberg, man may perhaps not be able to become an ontologically moral being himself, which in the end would mean being God, but one can envision a humanity living under moral laws. This goes along with what you were saying earlier about the categorical imperative, which tells one to act as if there could truly be a set of moral laws that function like a nature, or what Kant calls the "typical" in the second *Critique*.[21] Yet I think one has to say that humanism has truly run aground from this point of view, that is, from all the points of view . . .

P.-P.J.: I'd like to ask you, concerning the figure of man that humanism tried to define and which does not seem tenable as such, how do you situate yourself in relationship to two important philosophical positions; first, in relationship to the famous passage in the *Letter on Humanism*[22] in which Heidegger points out that the *humanitas* of man is not at the level of being, and then, in relationship to Levinas, a young student fascinated like others by the sayings of the master, who would go on to speak of a "humanism of the other man,"[23] underscoring that, as for himself, the thought of man is not at the level of man.

21. Immanuel Kant, "Of the Typic of Pure Practical Judgment," *Critique of Practical Reason*, ed. and trans. Mary J. Gregor (Cambridge: Cambridge University Press, 1997), 58.

22. Martin Heidegger, "Letter on Humanism," trans. Frank A. Capuzzi and J. Glenn Gray, ed. David Krell, in Martin Heidegger, *Basic Writings*, ed. David Krell (New York: Harper Collins, 1993), 219–20.

23. Emmanuel Levinas, *Humanism of the Other* [Humanisme de l'autre homme], trans. Nidra Poller (Urbana, Illinois: University of Illinois Press, 2006).

J.-L.N.: One should clarify something about Heidegger's text. He writes: "Humanism . . . does not set the *humanitas* of man high enough."[24] Even though the author doesn't appreciate Latin words very much, he retains *humanitas* because he is speaking about humanism and he criticizes it for not being faithful to itself in the sense that it doesn't elevate the human character enough as such. It isn't necessarily the same thing to say that *humanitas* isn't at the level of being. But of course, what Heidegger means is that to think *humanitas*, one must leave the title of "man" behind for the sake of the title of *Dasein*, which signifies the "putting into play [*mise en jeu*] of Being."

As for Levinas, he says something else, because the "humanism of the other man" defines both a humanism that starts with the other—this is the great schema of Levinas: I am held hostage by the other, I am responsible for the other, I am in submission to the other—and a humanism of the "other" man. But then, to what point is that man "other"?

To respond to your question about how I situate myself in relationship to these two positions, I would say generally: I don't take a position; instead, I rely on these two alternatives.

P.-P.J.: I would like to refine my question about Levinas. You say that community as co-appearance or compearance is the appearance of the "pearance" [*parition*] of the "between." I remembered that Levinas wrote a work called *Entre nous* [*Between Us*][25]; are you speaking about the same "between" here?

24. Martin Heidegger, "Letter on Humanism," in *Basic Writings*, 210.
25. Emmanuel Levinas, *Entre nous: Thinking-of-the-Other*, trans. Michael B. Smith and Barbara Harshav (New York: Columbia University Press, 1998).

J.-L.N.: What's clear is that the "between" comes first, because it's a way to dig deeper perhaps into what "humanism" may mean or may not mean anymore. If the word "man" signifies something, it's language at the very least. One can say many things about the animal, one can even note the presence of prelinguistic elements in the animal, one can say whatever one wants, but man and language are one; there is no man without language, and there is no language without man. If one supposes that there are other beings elsewhere, if communication is possible—as science fiction tries to depict sometimes—we're always referred back to language. I can appreciate that we don't limit expression to language, to languages, that we broaden it enough to include a group of signs that contain indefinable impressions, feelings one has in the presence of one another. But here the importance of the "between" would be underscored even further, and this time, almost as a consequence, the "between" would go beneath the level of the human being. What is the world—or the worlds—if not precisely the possibility of the "between"?

Something happens between things, which means, first, not that there exists "something rather than nothing," but a few things, *some* things. A thing does not mean anything, in Hegel's sense of the One that is its own negation. A thing, meaning more than one thing, means at least two things and thus necessarily three things: thing A, thing B, and the relation between the two, that is, the "between" the two, which relates the one to the other and separates it from the other at the same time. Without a doubt, the great invention of the Christian trinity is to have thought about God in three persons, the Father, the Son, and the Holy Spirit; and it's not by chance that this conception of the Divine Persons prompted the East-West Schism between Orthodox

Christians and Roman Christians[26]—the former considered that the Spirit proceeds from the Father, and the latter that the Spirit proceeds from the Father and the Son. It remains the case, for me, that the "between" comes first and that the entire problem of the one, the more than one, the "with" perhaps refers back to the story of Adam and Eve, as well as that of Cain and Abel. One recalls that the former is condemned by God when he claims that he's not his "brother's keeper."[27] Cain isn't allowed to say that he's indifferent or claim that he's alone. Yet this question of the connection, the relationship—it's as if it's avoided by philosophy from the start. Even though there's no "subject" in all of ancient thought, it's still the case that there is neither an "us" nor a consideration of co-presence or co-belonging in it. Sure, there is the City, several people together, and the question of how to rule, how to manage a multitude, a consciousness of the fact that interests can be opposed to one another, that some exercise power over the others. But doesn't this situation relate to what we were speaking about a moment ago, about the truth as verification, that is, about the fact that language, grasped from the outset as *logos*, is taken to be something that can account for itself? So isn't there something that was dismissed from the outset, namely that language doesn't have to account for itself, or that to account for itself, in the case of language, doesn't involve verifying itself by coming up with its own reasons, but rather, if one can say so, accounting for itself in the fact that one speaks, that one addresses.

26. The East-West Schism of 1054 is generally presented as a confrontation over the acceptance or refusal of the Latin expression *filioque* ("and of the son").

27. Gen. 4: 9–10.

P.-P.J.: Language can only justify itself by telling the story of the origin of language through language . . .

J.-L.N.: And in language, something will always arrive that only language can designate, and which also goes beyond language, and which consequently will never be able to be subjected to logical auto-verification.

P.-P.J.: Based on what you say about language, one could open up this reflection to the shock of the very thought of the "auto," as you indicated in one of your pieces from 2002:[28] "The form of life that has grown old is that of autonomy. Autonomy of premise, autocracy of choice and of decision, auto-management of the identical, auto-production of value, of sign and of image, auto-reference of discourse, all these are used up, exhausted. . . ."

J.-L.N.: Yes, it's not an exaggeration to say that an important part of our culture emerged under the influence of the "auto." To be, do, and think for oneself . . . One can't forget that these imperatives of humanism certainly played an emancipatory role. But in the end—and the most demanding philosophers always knew this, Montaigne, Pascal, Nietzsche, Hegel himself if one understands him, Marx too and of course Kierkegaard—the "auto" is not . . . self-sufficient [*auto-suffisant*], one might say. Man does not found himself, nor does man fulfill himself. He "infinitely surpasses man." And this is true for both the collective and the individual: The idea of "community" quite clearly implies (through communitarianisms) the danger of shutting oneself off in self-sufficiency [*auto-suffisance*]. And "number," which we have been talking about, indicates both the risk of taking the

28. Jean-Luc Nancy, *Philosophical Chronicles*, trans. Franson Manjali (New York: Fordham University Press, 2008), 9.

pure amount of a large number to be self-referencing [*auto-référence*] (the immense problem of "majorities" or of the appeal to the "masses," or the "headcount" of demonstrators . . .) and therefore also the necessity of thinking beyond the "majority" and the "community." It's an obligation for us to think about the multiple as dis-position (not a dispersion), as dis-tinction even (with all due respect to Bourdieu . . .) and at the same time as connection and communication, which isn't "unity" or "pure multiplicity," but "uniting," "meeting," "assembling" . . .

Community

P.-P.J.: We've been focusing on the question of world and number. Simultaneously, we're confronted with the question of community and number, which demands the same insistent interrogation: Do we have the necessary concepts to think this proliferation or do we have to invent a new ontology? I'd like to invite you to first clarify this notion of community by differentiating it from related notions, such as, for example, crowds, which inspired Baudelaire and sparked Benjamin's thought, or masses, classes, and the multitude.

J.-L.N.: It's interesting to take up a series of terms as you're doing because it almost spells out a history. I realize this now because you say "crowds," "masses," "classes," and "multitude"; one can add "people," which has always flowed through these notions, and "community," which is like referring back to a lost love who is found again and then

lost anew perhaps . . . This history is important because it simultaneously accounts for an increase in number, which was actually an increase in number within countries in modern civilization and then in the industrial revolution, and for a change in the perception a society had of itself. You mentioned Baudelaire and Benjamin. There's a moment in which modern society perceives itself as a society of crowds, which perhaps in some respects wasn't completely new. For example, in the seventeenth century Boileau mentioned it in one of his satires, "*Les embarras de Paris*" [The Troubles of Paris], even though the society of that time did not truly perceive itself as a crowd.[1] One may recall Horace's expression: *Odi profanum vulgus et arceo*,[2] heard as a condemnation of the tastes and opinions of common people [*le vulgaire*]. A Roman from that time could sense something of the crowd in Rome and confuse it with the plebes, and this is still the case when one speaks about the modern crowd. Which means that it's a purely urban phenomenon—it's always in a city that the crowd appears as a crowd. In the countryside, when peasants used to gather in the context of a war or revolt, one would speak about troops or gangs, suggesting a kind of swarming and proliferating, which not only corresponded to an increase in number, but also a collapse of what offered relatively natural frameworks or places of coexistence, which were, in reality, communities.

1. [Boileau-Despréaux, *Satires*, ed. Albert Cahen (Paris: Librarie E. Droz, 1932), 83–89.—Trans.]
2. Horace, *Odes* III.1.1, 22–23 BCE. ["I shun the uninitiated crowd and keep it at a distance," Horace, *Odes and Epodes*, ed. trans. Niall Rudd (Cambridge, Mass.: Harvard University Press, 2004), 141; "I have no use for secular outsiders, / I bar the gross crowd," Horace, *Odes*, trans. James Michie (New York: Duke University Press, 2002), 117.—Trans.]

P.-P.J.: It's hard to forget a crowd that was very famous, one could say, the crowd sung by one of the last century's most popular artists, the crowd of Edith Piaf.[3]

J.-L.N.: Absolutely: "Carried away by the crowd that drags us along . . ." This song reminds me of an American book that received a lot of attention in the 1950s: *The Lonely Crowd* by David Riesman.[4] It's a very apt expression because, since the nineteenth century, what was considered to be characteristic of the crowd is that one is alone in it: The crowd is a numerous group, a tumult of movements that goes in every direction and nowhere. But it's also a gathering that can be subject to passions, panic, commotions, rage, enthusiasm . . . Hence the attention given to crowd phenomena since the start of the twentieth century.

P.-P.J.: On this note, you wrote an article some time ago with Philippe Lacoue-Labarthe, "La panique politique,"[5] which brings me to my next two questions: Are there political affects, and should one think about social bonds through Freud's notion of "identification" (which he was never completely satisfied with)? And in the end, is it possible to determine what belongs to the order of the affective if, in a certain way, community is also a shared affect?

J.-L.N.: Every word you've used (crowd, mass, etc.) could be distinguished from the point of view of affect because behind these words lies the idea of community. Yet the idea

3. The song *La Foule* ["The Crowd"] was performed by Edith Piaf in 1957, with lyrics and music by Michel Rivgauche.
4. David Riesman, *The Lonely Crowd* (New Haven: Yale University Press, 1950).
5. Philippe Lacoue-Labarthe and Jean-Luc Nancy, "La panique politique," in *Retreating The Political*, trans. Simon Sparks (New York: Routledge, 1997), 1–28.

of community has been defined by affect ever since Ferdinand Tönnies introduced the distinction between "community" (*Gemeinschaft*) and "society" (*Gesellschaft*).[6] One is a gathering centered around inwardness, around the shared intimacy of an affect; the other is the organization of the balance of power or interests, and contracts that rely on a cold affect. Here it's hard not to think of Zarathustra's statement: "State is the coldest of all cold monsters,"[7] though of course it's out of the question to mix up society with the State. In any case—and only if we come back to this issue—what interests us, for now, is the crowd as a mode of gathering, as the true witness from the point of view of being-together [*l'être-ensemble*] in our modern and contemporary era. We're still in the era of crowds, even if these crowds have taken on certain aspects that have transformed them into something else perhaps. For example, the group of spectators at a great game is united by a common interest but they are susceptible to enthusiastic or frantic behavior. Let's also think about rock concerts, which then became "raves" or "techno" concerts: These are gatherings that have certain aspects of the crowd while aiming to be something else, like a community, a communion.

P.-P.J.: This makes me think of a talk called "The World Rock Scene"[8] that you gave at La Villette,[9] in which you

6. Ferdinand Tönnies, *Gemeinschaft und Gesellschaft. Abhandlung des Communismus und des Socialismus als empirischer Culturformen* (Leipzig: Fues's Verlag, 1887).

7. Friedrich Nietzsche, *Thus Spoke Zarathustra: A Book for None and All*, trans. Walter Kaufmann (New York: Penguin, 1978), 48.

8. Jean-Luc Nancy, "La scène mondiale du rock," in *Rue Descartes* 60 (2008).

9. [La Villette is an area in northeast Paris that contains a museum of music.—Trans.]

remarked simply that rock emerged in the postwar period, that is, after the failure of several attempts to develop communities, which took a bad turn, and at the same time, at the end of the era of metaphysics . . .

J.-L.N.: After the notion of "crowd," you mentioned "mass," a word that we've almost forgotten about today, though it used to be very present, perhaps until after the postwar period. The adjective "working" frequently accompanied it: "the working masses" was an expression that was used particularly in a positive sense, by people who were involved in social conflict. But the laboring masses could also . . .

P.-P.J.: . . . be dangerous. One recalls Louis Chevalier's book in the 1950s, which speaks about "laboring classes and dangerous classes."[10]

J.-L.N.: The word "mass" comes later than the French Revolution. In fact, the mass is the idea of the crowd, but considered as a true togetherness, and so the idea of "laboring mass," taken positively, evokes a force, precisely that of the mass. In a pejorative sense, the notion of "dangerous masses" refers to the power of the uprising of these same masses. But I think the sense of "mass" has become quite mixed up with that of the "crowd" as well as with one of the two main meanings of the word "people"—the lower class people [*le bas peuple*] or little people [*le petit peuple*]. "Mass" is thus a forgotten word today because we've given up on a certain vocabulary of struggle in which "mass" used to either refer to class in a positive way, or to the majority of society contemptuously in a repulsive way. Today this is also the case

10. Louis Chevalier, *Laboring Classes and Dangerous Classes in Paris During the First Half of the Nineteenth Century*, trans. Frank Jellineck (New York: H. Fertig, 1973).

with the word "people," which is almost never used in a pejorative way. When someone says "people," one is supposed to hear sovereign people, the dignity of the people, etc. Yet our society, which is unable to acknowledge that there's a difference between an elite and a people, enacts this very difference even more so despite the fact that this hierarchy is less and less indicated symbolically (Bill Gates and his kind are just like you and me).

P.-P.J.: Whether one thinks about Georges Sorel,[11] Freud,[12] or Elias Canetti,[13] for example, one should mention how recent this interest in the phenomenon of the mass is, and in the collective in general, which appeared as a new kind of reality that we realized we didn't know how to think about.

J.-L.N.: Then comes "class," a word that's much older than its Marxist usage because, in fact, it was already used in Rome (*classis*). Class is actually a way to classify a society, to indicate a social stratum, a group of citizens with an official administrative or legal criterion. With the French revolution—the "working class" appeared in 1797—a classification came that was not handed out by the administration nor by the law of society, but was derived from an analytic view of society. The difference between class and mass doesn't actually come from an instinctive view of a society that sees itself as a crowd or mass; this distinction pre-

11. Georges Sorel, *Reflections On Violence*, ed. Jeremy Jennings (New York: Cambridge University Press, 1999).
12. Sigmund Freud, *Group Psychology and the Analysis of the Ego*, trans. James Strachey (New York: Norton, 1959).
13. Elias Canetti, *Crowds and Power*, trans. Carol Stewart (New York: Farrar, Straus and Giroux, 1960).

supposes a tool of analysis that establishes how a society is arranged or distributed, thus raising the question of the law of this distribution.

We're coming now to the notion of "class conflict." This expression had a strong impact when it first appeared, and it became a kind of necessary point of reference for at least a century—let's say from 1880 to 1980. The enemies of class conflict could not pretend to be participants on the side of the bourgeois class, yet they had to construct complicated intellectual operations to disprove its existence. Frankly, they could deny the existence of the conflict, but they could not completely deny the existence of classes. The debate concerned the conflict more than the classes; how to calm class conflict in favor of an understanding between the classes, a share of the company profits for the laboring classes or the employees, etc. But for a very long time, the "class" tool of analysis, with or without the indication of conflict, was unavoidable; the "working class" was the exemplary class, and the bourgeois class, which was more differentiated, didn't agree as much to be called bourgeoisie.

I'm still very struck by the fact that we've completely abandoned this vocabulary after this century, which was permeated by the idea of class (except when fascisms actually wiped out the opposition between these classes with a "mass" that was transfigured into a people while the people themselves were transfigured into the "people's community" or *Volksgemeinschaft*). One should take into account the critical analysis of Marxism that came from within Marxism itself and leftist circles—I'm thinking in particular about the positions that Jacques Rancière has taken. It's remarkable that at a certain moment this author completely refused to analyze in terms of class in order to replace this notion with the notion of the "no part" [*sans part*] or those who do not

really take part in the City.[14] There's no politics unless the "no part" manifest themselves in a movement in order to claim or demand their right to have a part. Rancière, I think, wanted to refuse the idea of an opposition between classes because it would have to go through a reversal of domination by way of class dictatorship, which Alain Badiou to the contrary still considers necessary. For Badiou, of course, a dictatorship of the proletariat still needs to be put in place at a certain point. Rancière made this entire working class culture known because he was almost the only one to work on it. What's surprising is that Rancière's position almost turns the character of the conflict into a recourse that can no longer be the instrument of a party's calculated politics, rather than making the character of the conflict a secondary determination, even though he doesn't dismiss that the conflict may take the form of a revolt or insurrection. I also think that this thinker's position is connected to a loss of confidence in a history whose aim is the elimination of classes. We know that in the last thirty years, the gap between the "rich" and the "poor" has increased considerably, from every point of view, and the objective situation of confrontation has intensified. But the self-interpretation of society is no longer expressed in terms of conflict. This thought's key word, "exploitation," has been replaced by "domination"; one may wonder why this is the case . . .

When we used to speak of exploitation, we thought we were able to identify the exploiter, the capitalist in his individual form, with his top hat and cigar, who makes the worker work and extorts surplus value from them; this simply consisted in recalling Marx's analysis. Still today, no one

14. Jacques Rancière, *Disagreement: Politics And Philosophy*, trans. Julie Rose (Minneapolis: University of Minnesota Press, 2004).

would dare say that the extortion of surplus value doesn't exist. But the notion of exploitation and the notion of class conflict along with it were connected to the idea that one could calculate surplus value. Surplus value has been completely given up on. Still this is what Marx pursued in all his work, just as others did. But the incalculable character of surplus value lies in the fact that what Marx considered to be value in itself—absolute value, that is, the value of human work, not only in terms of productive force but as the truth or reality of human beings expressing themselves in work—cannot be defined or quantified. So it remains true that some work for a wage, and we no longer try to say whether it pays a just amount for the value of their work, and at the same time, this wage is incomparable to what for others is actually not their wage but their income, the profit they make off their capital.

P.-P.J.: We can identify another gimmick in the relationship of exploitation. In general, the one who exploits is concerned with the workers' survival but not with their quality of life. The exploiter's gimmick, then, consists in having the workers themselves produce the objects that they must acquire in order to live the ideal kind of life that the exploiter embodies. In almost every economy that relies on the idea of "consumption," it's a question of putting forward a system of values—the values of those who dominate—and presenting them as desirable, common, and able to be shared by all.

J.-L.N.: Yes, you're right. What this actually means is that, in this entire issue of the classes, we end up with a re-homogenization of society. But it takes place, as you suggest, by copying an image, the image of the dominant classes, which is nothing other than the greatest power, financially speaking, to acquire what everyone is supposed to long to possess.

P.-P.J.: Whether one possesses them or not, the same values are valued.

J.-L.N.: Exactly. In fact, the values that are valued are always very well defined by Marx as general equivalency, or money; the value that's valued is the value into which everything can be converted at any moment. We're also no longer in the realm of the difference that existed in the past between a prince's possessions and a craftsman or peasant's possessions. Consumption opens up another realm entirely and refers to the greatest number in a way that's even more deceitful or perverse one could say. The society of consumption is not only a society that's regulated by a sort of endless desirability for a growing quantity of things that are presented as ends in themselves, even though they are only means of sustaining other things. It's also a society that favors number, even a large number of objects. There's a value in a large number itself, in accumulation for accumulation's sake.

P.-P.J.: What you're telling me reminds me of a very combative text by Gérard Granel in which he speaks about teaching and remarks that the university is already entirely "commodified," meaning that culture itself is part of a social behavior of accumulation.[15] One "does" the exhibitions, for example, a practice that characterizes a class or social group. One has to have seen this or that.

J.-L.N.: Yes. Speaking of which, the recent success of certain exhibitions is something that perplexes me because I'm torn between the description you're offering and the desire

15. Gérard Granel, "Appel à ceux qui ont affaire avec l'Université en vue d'en préparer une autre," in *Erres* 9–10 (1980). Reprinted in *De l'Université* (Mauvezin: T.E.R., 1982), 77–96.

to resist, to say: "Come on! It's consumption, even though it's not the same as watching television all day."

P.-P.J.: I may have been mistaken in my example, which was that of art, because my remark was about art exhibitions, and was based perhaps on an "indignation," which itself relies on a certain conception of art.

J.-L.N.: When one thinks about these exhibitions, the recent one on Monet, for example, that had to stay open overnight, I wonder if there's not another desire that goes along with the consumeristic excitement, the desire perhaps to encounter this thing that we call a work of art, which has always been distant and which has now become closer.

P.-P.J.: It's the same for tourism in a way.

J.-L.N.: Yes, it's the same for tourism, it's true. One could almost say that in consumption, which in fact is full of the idea of accumulation and is permeated by general equivalency, one finds both the large number as a value in itself somehow, and the conversion of a large number of people into a large number of things. This society of the crowd, mass, and class has become society of travel, movies . . .

Could the notion of "multitude" assist us in our situation in any way? This word was very recently brought into theoretical vocabulary, notably through the work of Antonio Negri and Michael Hardt[16] and in the journal *Multitudes*. I have the feeling that we've been wanting to actually take back the large number with this word at a moment when and in a condition in which we're not finding a form to seize it with: "people" was forgotten, "mass" was in rough shape, and

16. Michael Hardt and Antonio Negri, *Multitude: War and Democracy in the Age of Empire* (New York: Penguin Press, 2004).

"class" was an organized form . . . The "multitude" is a plurality in itself; it is considered to be, by itself, what was expected of class, that is, a certain force, a dynamism. Multitude or multitudes are by themselves energetic; they do something, but the thing they do isn't within the order of the fight, which implies organization and engaging head-to-head. Instead, multitudes produce something of the order of an internal agitation, sometimes a deconstruction, a destabilization, a mobilization. We're witnessing all kinds of collective movements—more and more frequently for economic motives, and for ideological reasons ("marriage for all") as well as for political ones (the "*indignados*," *occupy*)—in which traditional organizations are not very present and in which the temporary facilitators typically don't last long. In the same vein, the so-called "social" networks (a strange name as if society was happening there, which is actually not entirely wrong!) don't set up any "party" or "union" or even "movement," but rather shape malleable, metastable groups . . . For Negri, these movements bring desire and libido into play directly, as he explains in his book about Venus.[17] And, in fact, one has to talk about collective affects. I'll come back to this if you don't mind.

But first I'd like to call for caution: I understand the movement that may have led to thinking in terms of affects, but at the same time, I'm very skeptical of this because I have the impression that, as a result, an unintentional converse reaction is taking place. (I'm not accusing Negri or others of being "deceitful servants of capital" in the words of the anti-imperialistic expression that dates back to the wars of liberation.) Having abandoned the idea that there's a historical

17. Antonio Negri, *Kairos, Alma Venus, Multitudo. Nove lezione impartite a me stesso* (Rome: Manifestolibri, 2000).

subject of the conflict—the class enemy—one places confidence in the non-organized swarm; I have the impression that this is already over. What could have presented itself as the possibility of the emergence of another form of subversion, or at least one of transformation, isn't talked about much nowadays.

P.-P.J.: If one chooses to remain in an irenic vision of the relationships between human beings, how does one manage to think about conflict while deconstructing traditional concepts? I'm thinking very specifically about what Jacques Derrida said when he returned from Prague, which you and Philippe Lacoue-Labarthe mentioned in your book *Retreating the Political*.[18] For example, how would one deconstruct the notions of freedom, rights, and the subject despite the fact that for some these are the weapons they have at their disposal in the heat of the conflict?

J.-L.N.: I think this issue has changed somewhat. At the time of the Prague events, so to speak, when we were deconstructing, say, the notion of freedom, it's true that we'd find ourselves in a kind of contradiction in relationship to people who were purely and simply undergoing imprisonment and being deprived of freedom. We couldn't speak to our audience about deconstructing a freedom they didn't yet have. It was no less true—I already thought this at that time—that we could legitimately say that once they would have our freedom, they would find themselves confronted with the problems it entails.

P.-P.J.: Which does seem to be the case after the fall of the Soviet regimes.

18. Philippe Lacoue-Labarthe, Jean-Luc Nancy, *Retreating the Political*, trans. Simon Sparks (New York: Routledge, 1997).

J.-L.N.: Yes, and I could address the same issue now in a more contemporary way. Some Chinese people read an interview in *Libération* in which I touched upon the idea of emancipation.[19] I said that we spoke a lot about the emancipation of humanity in order to oppose all the civil and religious tyrannies of the Ancien Régime that society endured and also all the tyrannies that came after it. Nevertheless, the expression "the emancipation of humanity," which no longer holds much value, isn't entirely interchangeable with that of justice. Nowadays, the whole world is emancipated at least potentially in terms of law, even though some enormous injustices continue to exist. Still one continues to stumble on this word "emancipation"—a leftist word, perhaps from a more refined left than the former Marxist left—and in the end its endurance brings us to ask the question: What is an entirely emancipated humanity? More precisely, from what is humanity emancipated? This question is close to the question of alienation, this word of Marx, who seems to call for a disalienation that's an integral reappropriation of something—we don't even know what it is precisely, or even whether it makes sense to say that it took place before or that it will take place later on.

This interview was going to be published in Beijing in the journal *Thinkers*. Its editors translated it and asked me to add a few explanatory comments, arguing that the idea of emancipation very much continues to represent something for the Chinese. But what does it represent for these men and women? The emancipation from the Chinese regime . . . I agreed and tried to say very quickly what the Western history of the word and thing is, indicating that emancipation

19. "Le sens de l'histoire a été suspendu," interview with Éric Aeschiman, *Libération*, June 4, 2008.

is probably not always and everywhere an empty word, that one might really need to be emancipated from an authority, a tutelage, a despotism, a tyranny, and so on, but that at the same time, a big part of the experience of the modern world leads one to assess that there's no absolutely emancipated subject either. The word "emancipation" comes from Roman law: An emancipated slave became a fully free man. Today, on the other hand, it's perhaps no longer possible to think about an absolutely emancipated human being.

P.-P.J.: You wrote that, in modernity, something new lies in the fact that it continues to speak of emancipation but without knowing who is emancipated or for what aim. Here it's a question about the possibility of realizing an identity that one appropriates for oneself.

J.-L.N.: Absolutely. And we're dealing with a question that's come up before: Who? We don't know who we emancipate— we say it's man, but actually, since we don't know who man is, we don't know who we emancipate . . . The same question arises when it's a question of emancipating a "people"; "who" or "what" are we speaking about?

People and Democracy

J.-L.N.: I once gave a talk at a conference in Cerisy that was dedicated to Jacques Derrida and entitled "Democracy to Come"[1]—I'd written a text on the notion of "people." After I'd finished my paper, Derrida said to me: "I would've said everything you said, but not with the word "people"; I replied, "Okay then, but give me another word." He answered, "I don't know, but not 'people.'" This small anecdote is interesting because it shows that Derrida has the same hesitation with this term as he does with "community" ("too Jewish") or "fraternity" ("too Christian"). But actually, "people" is different . . .

P.-P.J.: It should be noted that the title of your talk was a fragment of a lyric . . . A lyric of Méhul's *"Le Chant du départ"* ["Song of the Departure"] and more specifically the

1. *La démocratie à venir: autour de Jacques Derrida: actes du colloque tenu à Cerisy-la-Salle du 8 au 18 juillet 2002*, ed. Marie-Louise Mallet (Paris: Galilée, 2004).

notes along which one is supposed to sing: *"Le peuple souverain s'avance . . ."* ["The sovereign people comes forth . . ."] This music was played before you began speaking at the opening of the talk . . .

J.-L.N.: I'd chosen this part of the score as a title for the talk with the intention of getting closer to what Derrida had said: not to mention "people" in the title. At the same time, I wanted to affirm this notion of "people" in precisely this context—the sovereign people coming forth, who are in motion, who aren't here—but without letting those words or their signification be heard. What does this refusal or reluctance concern?

It's a refusal of a word that's been used far too much for identitarian, or even overidentitarian, affirmations. This conference took place in 2002; perhaps Derrida still had in mind all the things that surfaced as the former Yugoslavia was being torn apart and peoples affirmed themselves, an affirmation that isn't over yet in a way: the Kosovar people, the Macedonian people, the Bosnian people . . . Still what Derrida expressed, through his discomfort, the discomfort of our current philosophical situation, was this: At certain moments, we lack the appropriate words. For example, if one wants to avoid the term "subject" because one finds it too tied to the Hegelian tradition, if one adopts the suspicion for grammar that Nietzsche speaks about, what do we use in its place? I gave this talk with the word "people," a word I haven't used since very much, except of course in the book called *Identity: Fragments, Frankness*,[2] which, in fact, is a critique of the identity of a people. Yet I really believe in the core of the argument that I developed in this talk, that is, that there's indeed something like a people and that it's in the nature of

2. Jean-Luc Nancy, *Identity: Fragments, Frankness*, trans. François Raffoul (New York: Fordham University Press, 2014).

things that there are distinct groups that are separate from one another. It can't be the case that humanity is only one group, and this is perhaps a weakness of another song that proclaims: "The international will be the human race . . ."

P.-P.J.: In 1944, the Allies organized a concert that presented all the national anthems together, which was conducted by Arturo Toscanini. The anthem that was presented for the Soviets was *The International*, and it was therefore heard as the anthem of a nation . . .

J.-L.N.: But specifically as a nation whose vocation was to enlarge itself. Similarly, for a moment, a brief moment, the French nation—the Great Nation, as one called it then—could be thought of as being destined to become the nation of all of Europe. Foreigners received the right to vote at the National Convention, and for a very short time, too. Thus with the term "people," one touches upon something that's not very easy to categorize into supposedly natural, ethnic identities ("ethnic" comes from *ethnos*, which signifies "people"). A people is not necessarily ethnic at all, and at the same time there are ethnic realities that contribute to the realization of peoples. So there are groups with physiological relationships that have characteristics that don't necessarily determine what we've attempted to call "races." There really are biological and physiological characteristics that differentiate groups of human beings from one another. On this point, I remember that Georges Canguilhem took the Chinese peoples' rate of urea as an example, which is constitutively different from ours.[3] And within one ethnic

3. Georges Canguilhem, *The Normal and the Pathological*, trans. Carolyn Fawcett in collaboration with Robert Cohen (New York: Zone Books, 1989).

group, there are subdivisions, families of people who can be distinguished by their temperament, physical appearance, gestures, and so on. I've always been very interested by "types." Sometimes when I see people I say to myself: "This person belongs to a type," without this effacing their individuality. I find it quite fascinating that there are physical types; not everyone belongs to a single type, but some people are more "typical" or "type-oriented" than others.

P.-P.J.: The similarity between these two adjectives is a very delicate issue; one thinks about all the possible repercussions . . .

J.-L.N.: Of course, but we're very severe, and rightly so, when it comes to "racial profiling" ["*délit de faciès*"]. If I say, "That guy seemed Swedish," my remark will probably be viewed as innocent. But if I say to you, "That guy seemed North African," one immediately feels the suspicion or hint in that remark.

P.-P.J.: This response is rooted in history.

J.-L.N.: Yes, but it continues to exist. One knows how ridiculous it is to hesitate when mentioning that a black person is black. One notices the difference between the discourse of overly politically correct people, who seem to stumble over the word, and an "emancipated" black person, who will say: "I'm black." Aimé Césaire invented the word "*négritude*."[4]

P.-P.J.: A word that got picked up by Léopold Sédar Senghor in a way that's perhaps sometimes problematic, like

4. This term appears in the first and only issue of *L'Etudiant noir* [The Black Student] (March 1935), in an article by Césaire called: "*Négrerie*."

when the author says in his work *Chants d'ombre*[5] that emotion is black and reason Hellenic. This distinction is as ambiguous as the one that's sometimes made between "sensitive women" and "rational men."

J.-L.N.: Absolutely, but one could go further, because if I follow your line of thought here I also think that it's not easy to completely dissociate an idea of the feminine and an idea of the sensible either, which doesn't prevent the fact that this femininity can also be present in a man. So I think "people" is actually an indication of something that exists, that must exist, but something that, for a long time, constituted itself through the exclusion of others, through relationships of hostility even. As we know, many "archaic" peoples called themselves "men": the Burkinabes, for example, are "free men."

P.-P.J.: The Franks named themselves in a similar way, with "frank" signifying "free" in that language. Hence the idea that the "French" are "free men."

J.-L.N.: Exactly. When I wrote *Identity*, I was wondering how we went from the concrete to the moral sense of the term "frank" because the term can refer to the quality of a material: one speaks of *cuir franc* [genuine leather], for example. During the talk at Cerisy, I tried to say that the identity of a people lies in making a self-declaration, in calling itself a "people." That's why I qualified "people" with the adjective "so-called," in order to play with the idea that "so-called" often signifies "alleged" (one should also note that one can never use "so-called" when speaking about a thing [in French], since only people can call themselves something). I found it amusing to suggest that a people "calls itself" some-

5. Léopold Sédar Senghor, *Chants d'ombre* (Paris: Editions du Seuil, 1945).

thing; and during the French Revolution, this is, in fact, what happened. The French people made a self-declaration, and the Revolution began with the Declaration of the Rights of Man and of the Citizen, and of the French people. I don't think the French people had ever declared itself as such before through anyone; the king declared himself "King of France" and by the same token all of his subjects were subsumed under or assumed by the royal declaration. The institution of the "sovereign people," which is not an empty expression, will probably give rise to dangerous political problems. But the "sovereign people" is perhaps first the fact that the people must be able to make a self-declaration, without any superior authority to declare it or institute it as such.

P.-P.J.: If one goes back to the "title" of your talk, one notices that this "so-called" people sings about itself. But when one sings, one has a voice with a timbre. So it would be interesting here to consider what you say about the voice and timbre in *Listening*.[6] With timbre, there's something that has to do with the singular. One knows for example the range of a tenor, but one wouldn't confuse the timbre of a Russian tenor with the timbre of an Italian tenor upon hearing it; they don't have the same timbre.

J.-L.N.: Indeed, one even detects singular timbres. I agree that this characteristic also gets indicated in various languages. I remain fascinated by a phenomenon, the coexistence of several languages of Latin (or for the most part Latin) origin: Italian, Romanian, Spanish, Catalan, Portuguese, and French. Of course, many particularities distinguish

6. Jean-Luc Nancy, *Listening*, trans. Charlotte Mandell (New York: Fordham University Press, 2007).

these languages from one another, but for the most part, they are related through the question of pronunciation. And one also knows that the different Spanishes that are spoken in the countries of Central and South America can be distinguished not only by their vocabulary but also through their accents. A Chilean man was telling me that he was translating *The Inoperative Community*[7] despite the fact that there was already a translation in Spanish. I was very surprised, to which he responded, "Yes, but it's in terrible Castilian!" When books from South America are translated into French, it mentions that the book is translated from Spanish, but the country is also specified. Certain groups developed specificities through lengthy and complex historical processes, always through the creation of original forms: Catalan Romanesque sculpture is different from Romanesque sculpture in the South of France, or from the Romanesque sculpture of the Asturias, for example. I really think one can say that a people makes a self-declaration through a set of forms. The larger problem this raises is knowing at what point it's legitimate to tell oneself that these forms were abandoned in history and that it's useless to try to take them up again or resuscitate them (what the Catalans are striving to do now, which doesn't have much of a future perhaps, even though these efforts bear witness to quite a strong affirmation). In his work *Jenseits von Schuld und Sühne*, Jean Améry titled one of his chapters "How Much *Heimat* [Home] Does A Person Need?" It's a serious question; although one knows very well the extent to which the word *Heimat* triggers horror because of how much it has been appropriated

7. Jean-Luc Nancy, *The Inoperative Community*, trans. Peter Connor, Lisa Garbus, Michael Holland, and Simona Sawhney (Minneapolis: University of Minnesota Press, 1991).

by Nazism, and before Nazism, by an entire land-based, identitarian ideology. But it's also true that without any Heimat, one is simply "without a homeland," without a place . . .

P.-P.J.: A stateless person . . .

J.-L.N.: Yes, except that if this situation results from a deliberate choice, I really think that in the people, there is something that speaks of a very profound and very necessary desire for a group to be able to acknowledge itself as a group. So the problem lies in asking oneself whether or not this self-declaration of a people has to take place in a way that this people always knows that it's only a "people" when it tells itself so. So it has to speak of itself and produce forms. I'm not speaking about "folklore," a term rooted in the word "people," which is only the moment of the forms' repetition in the most banal sense, doing the same thing again. Dressing like a bigouden does not revive the Bigouden country; there needs to be a declaration, and it must perhaps be another people at certain moments. I think that within a certain form of internationalism, there has been a kind of a dream of effacing any identity of this kind.

P.-P.J.: Yes, but so as to form only one people.

J.-L.N.: To form only one people, but actually, no one has been able to say what this people's declaration consists of. The end of the Soviet Union showed how many peoples needed to hold their affirmation in abeyance, and as this affirmation turned sour, curdled, and moldy, it reemerged in an archaic, vain, and most often murderous way.

I'd add, concerning the frequently noted ambivalence of the word "people," that "people" is close to "population," and that this latter term immediately brings to mind overpopulation and numerousness. What allows one to make sense out of numerousness is the people, which gets expressed in

forms that themselves are no longer numerousness, but suggest a "substantial" unity ("one" people, "one" nation), one might say.

P.-P.J.: Thinking about the people as numerousness is probably connected to the fact that it's very difficult—if not impossible—to think about the people as a "principle." In your article "Finite and Infinite Democracy,"[8] you point out that we speak of a "mon-archy" and a "demo-cracy," but not a "dem-archy." A people doesn't make a principle. Though it may be a resistance to the assumption of a principle.

J.-L.N.: Sure, but then resistance requires force, and *kratos* is also force.

P.-P.J.: This is another way to say that community is resistance to immanence.

J.-L.N.: Sure, if you like. Force, which may eventually get expressed as violence, doesn't let itself be reduced in every aspect to the dominant unity of a principle.

8. Jean-Luc Nancy, "Finite and Infinite Democracy," in *Democracy in What State?* trans. William McCuaig (New York: Columbia University Press, 2011), 58–75.

Political Affects

P.-P.J.: The people, which is an expression of force that bears witness to this resistance, is also the place where affects manifest themselves. We've mentioned it already; the multitude is also a reservoir of desire or *libido*; all of our thought is permeated by a question of trying to reactivate affect or the passionate. Think of *Libidinal Energy*[1] by Jean-François Lyotard, or *Anti-Oedipus*[2] and *A Thousand Plateaus*[3] by Gilles Deleuze and Félix Guattari. Negri inherited some-

1. Jean-François Lyotard, *Libidinal Economy*, trans. Iain Hamilton Grant (Bloomington: Indiana University Press, 1993).

2. Gilles Deleuze and Félix Guattari, *Anti-Oedipus: Capitalism and Schizophrenia*, trans. Robert Hurley, Mark Seem, and Helen R. Lane (Minneapolis: University of Minnesota Press, 1983).

3. Gilles Deleuze and Félix Guattari, *A Thousand Plateaus: Capitalism and Schizophrenia*, trans. Brian Massumi (Minneapolis: University of Minnesota Press, 1987).

thing from this. And even though I expressed some reservations earlier, I also want to underscore the importance of this aspect.

In fact, the question that sums everything up might be: Do political affects exist? What are they? One could go as far back as the theme of *philia* in Aristotle, but I'd like to return in particular to two texts that we've already mentioned by Philippe Lacoue-Labarthe and yourself—one entitled "La panique politique," published in 1979 in the second issue of *Cahiers Confrontation* that was edited by René Major, and the other, "The Jewish People Do Not Dream," a lecture you gave at a conference in Montpellier in 1980 entitled "Is Psychoanalysis a Jewish Story?" If we don't think about the social bond simply in terms of contracts, exchanges, and relationships of interest or power or force, then what about intimacy, which is longed for but considered to be lost in community? Can one grasp it in terms of affects or affectivity? You've already remarked that society itself is conceivable in terms of cold affects.

J.-L.N.: Yes, in terms of cold affects that tend toward the freezing cold, one could say, evoking Nietzsche once more, that the State is "the coldest of all cold monsters." This reminds us that the State and society can't be confused with one another, just like society and relationships . . . Because if "society" designates the sphere of interest and power relationships that must be managed, then society is rather "cold"— but one should add that this cold is not devoid of forms of heat . . . Passions are also at work in relations of trade, law, and so on. But if one thinks about all the relations together— beginning with "relation" itself—then one must also consider that any relation is a relation of affect: It's acceptance or refusal, assimilation or rejection, retraction, fear, identification, preference . . . It's as if throughout modern history

the "private" sphere had reserved warmth for itself, increasingly so, as cold was taking over the public sphere. This glacier spread progressively throughout modern history, basically since the end of the feudal system. In the feudal system, the relationship between the overlord and the vassal contained a religious, and thus at the same time an affective, aspect of fidelity, sworn faith, the vassal's pledge of allegiance, and so on. And so, if the feudal model had taken over, it's because it came after the demise of the Roman Empire (at least the Western one), in which civil religion had given rise to a very strong bond; this civil religion had degenerated into a formal ritualism and the Empire had slowly been collapsing for several centuries. Christianity, at least in the beginning, didn't yet represent a social bond even though it offered a very strong affective bond; it's been said that this religion presented itself as the religion of love or affect while also taking on an eschatology of salvation. It's probably not a coincidence that feudalism—a social-political model that comes from the Germanic people, which wove together religious and affective relationships—developed at this time.

The modern State that began to be developed at the time of Machiavelli and Jean Bodin then took the prominent form of the French monarchy throughout Europe. From the reign of Philippe Le Bel on, and during the history of its self-constitution throughout the lineage of the kings of France, this modern State, unlike the feudal system, is defined by sovereignty, a sovereignty that's directly opposed to divine sovereignty. What took place during feudalism gets reversed, and this reversal accomplishes all that had been present in Christianity since the beginning: the complete separation between the two kingdoms, between the two regimes of existence. When questioned about paying taxes, Jesus replied: "Give therefore to the emperor the things that

are the emperor's, and to God the things that are God's."[4] So all of the affective weight is anchored on the religious side, whereas on the political side, the disappearance of the affective is very visible, as one can see in Machiavelli, even if it's unfair to mix up the Florentine author with his "Machiavellian" image, as many studies, such as Claude Lefort's, have shown;[5] nevertheless, what remains linked to Machiavelli is the idea of the calculations that are needed to acquire and maintain power . . .

P.-P.J.: Very early on, already in Elizabethan theater, *Machiavels* became synonymous with *politics*. What was offensive during this time was the separation between the moral and the political; Claude Lefort explains this very clearly when commenting on the famous and "scandalous" Chapter XVIII of *The Prince*, "How a prince should keep his word."[6] The question, he says, is not about knowing whether the prince is virtuous—perhaps he is—the question is about knowing whether it's in the interest of the prince to seem virtuous.

J.-L.N.: Because Constantine dedicated the Empire to Christianity, Christianity became interested in the State and would ask specifically that the prince be virtuous. Thus, in the name of this demand, Thomas Aquinas, for example, could justify regicide in the case in which one could truly testify to the fact that the prince was not at all concerned

4. Matthew 22:21, *The Harper Collins Study Bible: New Revised Standard Version*, ed. Wayne A. Meeks (New York: HarperCollins, 1993).

5. Claude Lefort, *Machiavelli in the Making*, trans. Michael B. Smith (Evanston, Ill.: Northwestern University Press, 2012).

6. Niccolò Machiavelli, *The Prince*, trans. Peter Bondanella (New York: Oxford University Press, 2005).

with the happiness and the salvation of his subjects. One sometimes responds to this claim with the passage in Paul's *Letter to the Romans* (XIII) where Paul advises them to obey the authorities "because every authority comes from God."[7] But those who comment on this passage—and the passage itself if we put it back into context—actually show that, for Paul, the authority that's being spoken about is good in itself. One could say that throughout Roman history up until Caesar, citizens weren't worried about the threat of a tyrant. Cincinnatus, who'd been called upon for "dictatorship" twice, in 458 and 439, had been praised highly, and had returned after each time to work the plow by his own volition. On the other hand, the Greeks, the Athenians at least, were terrified of tyrants, and tyrannicide was seen as a heroic, virtuous act; one thinks of the honors that were given to the tyrannicides Harmodius and Aristogeiton.

To return to the topic of the modern State, one can say that, on the one hand, it's forced to constitute itself outside of the affective realm of religion if it wants to claim its full independence, which would come to be called sovereignty, but on the other hand, it would still be forced to seek to qualify itself affectively in several ways and at several moments. Henry IV provides an amiable figure because his religious conversion, which is entirely one of political calculus, is also set against an affective backdrop that is connected to the sharing between the Reformation and Catholicism. Louis XIII and especially Louis XIV always kept their distance and remained imposing. Louis XV was called, at least for a while, "the beloved." Finally, it's hard to forget the frequently remarked upon affective aspect of the French Revolution; the critique of the monarchy shifted into hostility toward

7. Romans 13:1.

Louis XVI and the Royal Family. Many historians have underscored that the episode of Varennes was decisive because the king's escape, which was felt as treasonous, indicated a breach of affective trust. The pathway to a constitutional monarchy had been closed, and the crisis of August 10, 1792 was brewing. Today constitutional monarchy, as it exists in the UK and somewhat in Belgium, Sweden, or Spain, could be considered to be an affective pole.

P.-P.J.: When one speaks of affectivity, it seems legitimate to mention the figure of the father. One still remembers the expression, "the little father of the people," which applied to the tsar as well as to Stalin. But this paternal metaphor can already be found in the very title of Robert Filmer's classic work, *Patriarcha, or the Natural Power of Kings*.[8] In order to justify the government's monarchic form and its absolute power, the author resorts to an analogy: The king is to his subjects what the father is to his children.

J.-L.N.: Yes, you're touching upon something extremely important. The question is this: Why are we facing a problem that's affective? One speaks about the people, one speaks about politics, one speaks about the relationship between the State and the people—today one comes across this very strange label of "civil society" [*société civile*][9] to designate the entire society without the State, outside of the State, as something separate from its own organ of government, whereas in the eighteenth century, this expression used to designate "citizen society," a politically organized society, as opposed to a barbaric, savage society.

8. Published in 1680 after the author's death in 1653.
9. [A French expression used to describe an array of non-governmental representatives from community organizations, NGOs, media, trade unions, universities, and religious groups.—Trans.]

I think this whole series of problems started with Greek democracy because one could actually be worried about the threat of tyranny. Rome, after its effective success, encountered the problem of rendering the emperor sufficiently "amiable" and started to achieve this by "putting too much onto" or overemphasizing [*surcharger*] his figure. What the very fact of inventing the Empire consists of is this: overemphasizing a figure, which would progressively lose its force of attraction. One can, in effect, call "putting too much weight onto" or overemphasizing first, the fact of creating the permanent title of emperor itself, there where permanent power's identity was the "republic" itself, and then, making the bearer of this title divine, creating the phenomenon of the "court," developing the image of the "empire of the world," and so on—all of this, one must recall, did not proceed from an already established theocratic order (like in Egypt, for example), quite the contrary.

P.-P.J.: Until Constantine, one could say, a figure that Paul Veyne speaks about?[10]

J.-L.N.: Yes. Paul Veyne doesn't use the word "affective," but when he mentions the moral and intellectual disarray of Constantine's time, it's actually the disaffection with the imperial figure . . . Let's not forget that the title had been held by Caligula and Nero among others. If we encounter these difficulties and questions, it's precisely because the beginning of our culture, the Greek beginning, corresponds to a rupture away from a model in which there was naturally a father, paternity, filiality, or at least what we refer to with these terms, which aren't necessarily the most accurate. In

10. Paul Veyne, *When Our World Became Christian: 312–94*, trans. Janet Lloyd (Cambridge: Polity, 2010).

any case, one can hardly ask the question of political, communitarian affect before the Greeks. The centuries of ancient Egypt have given us love poems, but very few, as far as I know, concern affective problems about the people in general, the Empire, that is, the pharaoh, and so on. Something from the affective was completely taken over or absorbed by the sacred; perhaps that affectivity did not even appear as such until there was a sacred, mythical system . . .

P.-P.J.: As I listen to you, I'm noticing that we use the word "affectivity" as if it were a positive attachment, which is equal to recognition and legitimization. Nevertheless, when Caligula speaks about the subjects of the Empire, he declares: "*Oderint dum metuant*"[11] [Let them hate, provided that they fear]—he actually plays with the affects of fear and terror. But these affects aren't the ones that interest us.

J.-L.N.: They're not the ones that interest us for a very important reason that's seen throughout the entire history of political theory: Fear is not enough to ensure the durability of a government. Despite Pascal's and Rousseau's assertions, everyone in the world agrees on saying that if we reach a political arrangement in which force becomes law, then it's no longer force. In a way, even if it's difficult to express it like this, force must present a figure that's somewhat "amiable" so that one gives it some trust. The true question is the question about trust.

P.-P.J.: This makes me think about your lecture in Cerisy in which, after underscoring the preposition *cum* in "contract," "con-tact," and *con-fiance* [trust, confidence, faith, be-

11. "Let them hate, provided that they fear," Suetonius, *Lives of the Caesars*, trans. Catharine Edwards (New York: Oxford University Press, 2000), 152. 2nd century AD.

lief], you reminded the audience of Paul Valéry's words: in order for there to be a people, there has to be at least something "fiduciary." This *confiance*, or shared "*fiance*," could also offer a path for reflecting on "faith" (*fides*).

J.-L.N.: Yes, and while agreeing with Valéry, one should perhaps also say that in order for there to be a *fiance*, there needs to be a people. Why this question? Very simply because in our tradition everything begins with an isolated subject, an individual. It's only afterwards that the problem of the other's recognition emerges, which Heidegger responded to well and also poorly. Well, because he dismissed all the other ways of recognizing the other, which were based on reasoning or empathy, by maintaining that what's given from the start is myth. Poorly, or insufficiently, because he didn't delve into an analysis concerning the thought of this myth. This is our task. In our tradition, almost no one, from Aristotle and his *philia* to Heidegger and his myth, really thinks this "being in relation to." So we rely on revolutionary, democratic fraternity, which is actually a Christian notion that refers to paternity (which is the reason why Derrida didn't like this "masculine" notion that refers to "phallocentrism" and patriarchal order; one can think about it differently in relationship to the "dead father" but I won't expound on this here).

P.-P.J.: We should recall that, for the French Revolution, the true national holiday takes place on July 14, 1790.

J.-L.N.: Yes, it was the *Fête de la Fédération*.

P.-P.J.: In Michelet's *History of the French Revolution*,[12] he very much insists on the fact that it is the day when we loved

12. Jules Michelet, *History of the French Revolution*, trans. Charles Cocks (Chicago: The University of Chicago Press, 1847). See, in

one another. We loved one another on the 14th, but we should have loved "the day after." Michelet deliberately plays with this subtle ambiguity: Is "the day after" the direct object of the verb "to love" or is it an adverbial phrase of time?

J.-L.N.: It's very beautiful. I understand the ambiguity that you're pointing out very well. Michelet's sentence simultaneously implies that one must continue to love and that one must love the fact that it will continue.

P.-P.J.: One must love for there to be a day after.

J.-L.N.: But, actually, we have a problem with the day after, which is the problem of the Revolution as well as the problem of simply prolonging.

P.-P.J.: Is it also the problem of the question, "What is to be done?"

J.-L.N.: Yes, exactly. It's an entirely different side of the problem, because "What is to be done?" signifies "What is to be done in an enduring way?" I'm trying to be done with this sort of turn backward, inasmuch as it's possible to do this . . . All of this recalls an image for us, which, of course, can only remain an image because we know nothing in the end about its inner, "intimate" life. We were speaking earlier about intimacy—a very important notion. Before the Greeks, before the City, there's a world—or several worlds, what have you—Egypt, Babylon, the Hittites, all kinds of

particular: the 1847 "Preface," 3–4; Book III, Chapter 11, "The New Religion—Federations (July 1798 to July 1790), 440; Book IV, Chapter 1 (July 1790 to July 1791), "Pourquoi la religion nouvelle ne pût-elle se former—obstacles intérieurs," in Jules Michelet, *Histoire de la Révolution française* (Paris: Gallimard, La Pléiade, 1939), 425, 432. [Book IV of Michelet's *History of the French Revolution* is not included in Cocks's English translation.—Trans.]

realities that are also represented elsewhere to us by the Chinese Empire and by tribal societies. And we don't regard the African empires as having the same exact appearance as the Mediterranean or Chinese empires; we're nevertheless referred back to a world or worlds in which one can say that intimacy isn't a problem, it's not a posited notion or one on the basis of which one has to interrogate oneself, nor is it a practical reality that would require modifications. For example, I remember when Lévi-Strauss describes a love scene amongst the Nambikwara people, perhaps at dusk, he says: "Couples leave, and one can hear laughter behind the brush . . ."[13] Some modesty remains, these people leave and I don't think there's any culture in which people don't isolate themselves somewhat to make love.

P.-P.J.: Even with the Cynics, what's shown publicly isn't shared sexuality, but solitary pleasures.

J.-L.N.: Diogenes masturbated in public, but Hipparchia, a cynic from Alexandria, one of the few women philosophers from antiquity, mated with her husband in the streets. There needed to be this extreme situation, a female philosopher and cynic for this boundary to be crossed, but this would be a question for anthropology or ethnology. Still, I have the impression that in general there's never a complete absence of intimacy in sexual intercourse and that at the same time, there are very many different ways to inscribe it in public space, which has to do with the way people lodge, lie, and arrange the spaces inside of their houses, huts, and so on. I'm mentioning these situations because sexual intimacy is

13. Claude Lévi-Strauss, *Tristes Tropiques*, trans. John and Doreen Weightman (New York: Penguin Books, 1992). [Nancy is paraphrasing the text orally.—Trans.]

an image of intimacy that comes to mind immediately, but more generally, what we imply by the intimacy of consciousness, the intimacy of each person within themselves, the inner self, and so on, is what we have a hard time knowing how to characterize or convey in ethnological descriptions.

P.-P.J.: Is it this same superlative form—because *intimus* is the superlative form of *intus*—that we find in Augustine when he speaks about God: "[. . .] more inward than my most inward part [. . .]": "*interior intimo meo*"?[14]

J.-L.N.: I was hoping we might come to this, actually. I wanted to say that it's surely not by chance that it's through Christianity—and effectively through Augustine—that this intimacy wasn't recovered but invented as a particular category of the superlative that's entirely connected with God. This is perhaps the great strength of Christianity, the discovery of a realm that was left untouched, or that had disappeared from those societies that were called "holistic." In these societies, there's a "whole" (*holon* in Greek means whole) that encompasses, but—and this is difficult for us to understand—this "whole" is not totalitarian. One can immediately assert, this I know, that a society with a caste system is extremely oppressive, and that's a fact. Nevertheless, we know that one would have to determine what a caste society is when it's not in contact with any casteless, but not classless, society. Today, many democrats in India ask for the repeal of the caste system, which really doesn't seem tenable anymore. But we must also acknowledge that we have no idea about what the true, inner life of a caste society is, nor what the inner life of imperial

14. *Intus, interior, intimus*: inner, more inner, innermost. Cf. Saint Augustine, *Confessions*, 3.6.11, trans. Henry Chadwick (New York: Oxford, 1991), 43.

Chinese society was with its Mandarin system, which seems incredibly strange to us. This implies, in fact, a very strong power that's capable of very strong oppression, but one that was able to function for centuries. Here we come back to Caligula's "oderint dum metuant": It's not possible for a social system to persist on the basis of fear alone. There needs to be a kind of adherence; something of what we call "intimacy" has to be able to occur, even before, I would say, it's recognized as intimacy.

P.-P.J.: So, being the good "Greeks" that we are, can we go as far as saying that even despotism, or tyranny, cannot achieve domination through fear alone?

J.-L.N.: Of course. Incidentally this is the sense of the "virtuous appearance" of Machiavelli's *Prince*; there would need to be a very detailed analysis of what "appearance" means here, because one first hears the hypocritical aspect of this demeanor or act that's put on.

P.-P.J.: "The tribute that vice pays to virtue," according to La Rochefoucauld's maxim on hypocrisy.[15] Even someone who has a cruel or perverse personality must be careful to present themself in a certain way. We can now concisely formulate the question that interests us: Why must there be something from the affective realm in order for political life to be possible?

J.-L.N.: We have to talk about affects when we speak about politics because two problems are at stake. The first problem concerns government in the broadest sense of the word, that is, the way to ensure relations and, as much as possible, the

15. La Rochefoucauld, *Maxims*, trans. Leonard Tancock (New York: Penguin, 1959), 65.

balance of forces and interests of a social group. The second problem concerns maintaining co-presence, cohesion—a word that's perhaps not strong enough—without which there's no individual presence. As we've mentioned before, one of the most important problems of our culture probably comes from philosophy's lack of interest in categories of the "between," the "with," and thus the entire *cum* in all of its forms. The reason is the following: Philosophy, which appears with the City in a way, as if it were necessary for it, is charged with thinking the political cohesion of this City. Yet at the same time, the City experiences a loss, an original deprivation of what was provided before with the group: trust [*confiance*], the group's self-recognition. For us today, this idea seems to belong to a communitarian identity, a voluntary identity that's looking for a nature, an essence, a figure for itself. This is what has made all of the thought about a community's "nature" or "figure" suspect for us. But one mustn't forget that this suspicion appeared because of the experience of fascisms, and Soviet communism, too, in a way, even if it's within fascism that it posed the most difficulty. What happened? Something that Georges Bataille saw very well: Fascism was the violent, unstoppable irruption of the motif of affectivity and a feeling of common belonging, beneath the level of social cohesion, that was precisely what democracy found itself to be lacking the most.

P.-P.J.: But one should then recall that the question of common co-belonging of which Bataille speaks is also connected to the question of sacrifice. And one could say that, in a certain way, Christianity is the end of sacrifice, unless we continue to think the sacrament of the Eucharist as a form of sacrifice.

J.-L.N.: I think the Eucharist represents the perpetual sacrifice of Christ. Through the Eucharist, the body of Christ

is incorporated into everyone, into each Christian at least. This incorporation is that of Christ's glorious body and his human—let's say historical—body from before the resurrection. Transubstantiation, which is what makes the body of Christ entirely present in a piece of nourishing substance that can be absorbed into the body of everyone, actually signifies that it's Christ's human body that once again joins the human condition indefinitely and joins what is mortal about it too. At the same time, Christ can only be ingested because he offered himself as a sacrifice and as the real, effective memory of his presence. So this presence, both his divine and human presence, is renewed indefinitely among human beings. One can interpret the host as both the sacred species—that is, as having at once the appearance of a human body, that of Jesus of Nazareth, and also the appearance of a glorious body, which is that of the same Jesus of Nazareth, only resurrected. This immensely delicate articulation contains a very important teaching of Christianity: This teaching is less about the triumph over death in the most banal sense of the term, and more about the possibility of being in the belonging of a common body. One mustn't forget that the doctrine of the Eucharist is continued in the doctrine of the Church as the mystical body of Christ. Some theologians employed this thought of the mystical body toward the totality, not only the totality of humanity, but also of nature. Christianity has had a very strong role in implementing a feeling of belonging, which is why it's the religion of love.

P.-P.J.: Your analysis brings to mind a word of caution that you expressed in a note in your work *Maurice Blanchot, passion politique*,[16] which concerns Blanchot as well as Georges

16. Jean-Luc Nancy, *Maurice Blanchot, passion politique: lettre-récit de 1984*, followed by a *Lettre de Dyonis Mascolo* (Paris: Galilée, 2001).

Bataille: No one can build a "case" or go to "trial" against the errors and political temptations of these two thinkers in the 30s without having first analyzed communion as it's put forward by Christianity.

J.-L.N.: Certainly. And this difficulty is also at work in another text by Blanchot, *The Unavowable Community*.[17] It's quite remarkable that in the first part ("The Negative Community") there's a passage in which Blanchot dismisses the communion with scorn, saying that all communion aims at fusion. On this point, then, he agrees with what I'd suggested. Yet in the second part ("The Community of Lovers"), he suddenly speaks out of the blue about the "eucharistic body" and, a few lines further, he mentions "the disciples of Emmaus." I noticed on several occasions that attentive and competent readers overlooked this moment in the text, as though this passage stunned its readers or was perceived to be banal even though it's not. Blanchot, then, somewhere in between the beginning and the end of his work, moves from rejecting the communion to affirming the gift and the sharing of the body of Christ (even if this name doesn't appear in the text), and it's put in the indicative as if it were a real fact: "was given to us." Thus Blanchot calls at the same time for the rejection of what has been called "fusion," the affirmation of what has been called gift and sharing, and the disappearance—absence, death, passage elsewhere—of the body, which has been given and shared. Blanchot tends to give "community" over to the experience of a relationship that's recounted in a novel by Duras,[18] a "disaffected" love in both senses of the word. This

17. Maurice Blanchot, *The Unavowable Community*, trans. Pierre Joris (Barrytown, N.Y.: Station Hill Press, 1988).

18. Marguerite Duras, *The Malady of Death*, trans. Barbara Bray (New York: Grove Press, 1986).

relationship is both symbolic (like Duras's literary account) and actual (like the Christ-like gesture, put in the indicative). So there's something like an appeal to a mythical foundation for the community, which remains "unavowable" because it has to do with the secret of sexual intercourse and refers to the mystery of a "gift of the body." One can't help but ask oneself whether this is a kind of extremely complex transformation of the relationship to myth, the need for which has been felt since Romanticism and which fascisms believed they were able to take hold of, even though the convergence of sex and Christianity is doubly qualified for keeping the fascist temptation at bay. Still this is a singular operation that remains strange; I'd have to go further into its analysis . . .

P.-P.J.: Does Blanchot's onerous position on this question recall what you were saying earlier about the effort to think something beneath the level of "bond"? You were speaking about "adherence," something "inherent," and you were indicating that these notions are close to the notion of "immanence." This closeness seems to be at the heart of the difficulty. In another context, in your effort to think about what's outside the world from within the world, you "invented" the word "transimmanence." It's this "almost immanent"—if we venture to formulate it this way—which is at the crux of the problem.

J.-L.N.: Yes, absolutely, because immanence, to quote Bataille once again, is "water in water," the absence of all distance between the thing and itself. One could say that in a sense, there's never any immanence because as soon as there's a world, there are things. As I like to say, there's not "something rather than nothing," there are "some things" in plural, "several things." It's perhaps in this way that one can point out a weakness in the foundation of Lacan's thought when he speaks about "the thing" as being the singular, unique,

absolutely unique real, which at the same time is the object or impossible term of desire. But isn't the error actually the attempt to name "the thing" in the singular?

Immanence would be the pure and simple unity, which is its "simple negation," as Hegel analyzes it.[19] The fact that the one is its own negation implies that there is never only "the several." Perhaps one could say that "the several" is the fate of the totality of the existent, and that man, as a being that speaks, is the being who must posit the existence of things. It's the existent who says existence, both for itself and all the rest of the world. This situation is our problem because in a "holistic" society, it's not only the people, the social or community group, which is gathered, but it's gathered with the nature that surrounds it; these are worlds that are populated with sacred animals and trees, with which human life is completely enmeshed, interwoven. Wittgenstein wrote very well in his *Remarks on Frazer's Golden Bough* that Frazer understood nothing about the people whose thought he deemed irrational or bizarre. If we place the idea of politics at a level beneath the Greek polis, one encounters worlds in which there is almost no separation between human society and a larger society where humanity makes up society— to retain this word—along with living and even inanimate nature. There is a co-herence or co-belonging of all the existents.

Regarding the question of a co-belonging that's "close to" immanence, once again we find a law that applies to all instances of proximity: Regardless of how close this proximity may be, there needs to be a distance in order for

19. G. W. F. Hegel, *The Science of Logic*, trans. George Di Giovanni (New York: Cambridge University Press, 2010). [Nancy is paraphrasing the text orally. Cf. 98–99.—Trans.]

proximity to be proximity. Besides, this law is also the law of touching, and, in fact, "contact" is a word that expresses it very well. This is probably the reason why touching, as Freud says, is the greatest and most universal of taboos, because touching borders upon what could be an interpenetration. And, in fact, as soon as there is penetration, there's no longer touching. This is why I like to say that, when one is talking about sexual penetration, one is twisting the sense of the words, because this kind of penetration is much more complex than the penetration of a knife into flesh.

P.-P.J.: An invasion.

J.-L.N.: Yes, an invasion.

P.-P.J.: This reminds me of a passage by Levinas where Levinas speaks about caress and sexuality, of an "'excess' of tangency—as though tangency admitted a gradation—up to contact with the entrails, a skin going under another skin."[20]

J.-L.N.: Yes, but a skin that goes under another skin that's not penetration. In the case of sexual penetration, skin is replaced by a mucous membrane, which itself is a tissue that's similar to skin, which is a surface element and pertains to a relationship with the external. In any case, touching displays proximity as such, which is not immanence. Here one could grasp the implication of this difference on the basis of certain psychoanalytic representations. What really irritates me, what I profoundly disagree with, is the representation in which one must learn to renounce a primordial unity, leave one's mother's womb, accept castration as the deprivation of a sort of omnipotence. If one can only think in terms of the necessity of

20. Emmanuel Levinas, *Otherwise than Being or Beyond Essence*, trans. Alphonso Lingis (Pittsburgh: Duquesne University Press, 1998), 187.

renouncing an always prior immanence, it's because of a sort of incapacity at the heart of our culture to start thinking in terms of separation, that is, in terms of relationship too.

The question of community emerges in that humanity which has left a prior state behind, which still remains in some places, in parts of Indian, Japanese, and African societies, as one might think. But at the same time, all of this is contaminated by contact with our own society, which has left behind a world in which there was a sort of given co-belonging, without this gift being a reference to an illusion of immanence; it referred to a co-belonging. We, who came later, say it's an illusion. It's the same gesture as that of the philosopher condemning myths because they lie. Much later, psychoanalysis established that the individual lies to him- or herself because they tell themselves their own myth. The difficulty truly lies here, which brings us back to the two previously mentioned values of the word "*politique*" and the two possible destinies of this word: On the one hand, the organization of common existence, the reduction of "the unsocial sociability of man" (according to Kant's well-known phrase),[21] conjoining antagonistic interests, and, on the other hand, assuming a sense or truth about this existence.

21. Immanuel Kant, *Idea for a Universal History with a Cosmopolitan Aim*, 1784.

Politics and Religion

P.-P.J.: Since the beginning of this interview, we've ac-
knowledged and reviewed two areas of thought: On the one
hand, the original co-belonging of the philosophical and
the political, to use the expression of Jacques Derrida that
you and Philippe Lacoue-Labarthe picked up in the '80s, and
on the other hand, concerning the notion of community,
the co-belonging of the political and the religious. What
remains to be looked at is how the philosophical, the reli-
gious, and the political interconnect. If one considers like
you do that Christianity took charge of the conduct of the
world for several centuries, what happens to thinking about
the world and politics after the "death of God"? More pre-
cisely, what's at stake in the "grave question" that's enun-
ciated in *Adoration* after recounting the etymology of the
word "enthusiasm": " 'enthusiasm' means 'passage to god' or
'sharing the divine': How can enthusiasm be saved from the

death of God?"[1] This concern seems related to your writing strategy, in the way you borrow a theological category—an excellent example of this is "creation ex nihilo"—and take it out of context while also trying to find something helpful in it.

J.-L.N.: You're asking a question that also has to be addressed to Gérard Granel. In the last article he published, "Far from Substance: Whither and to What Point? (Essay on the Ontological Kenosis of Thought Since Kant),"[2] Granel borrows from the notion of "kenosis"—which appears in Paul[3]—in order to specify that from then on it must be understood as "assigned to an ontological index that is no longer theological."[4] I remember asking him back then: What's this about? Can we leave the theological behind? Today, very briefly, and as a start, I'd say we can't. When we speak about "secularization"—as Hans Blumenberg observed very well in the questions that he addressed to Carl Schmitt—what are we talking about? Is it the complete transfer of the same content but in another context? If one takes a fish and puts it in a dry place, it can no longer live. Is it a metaphorical displacement? But then what does metaphor signify? Concerning Carl Schmitt, I'm very grateful to Jean-François Kervégan for having clarified these questions in a recent

1. Jean-Luc Nancy, *Adoration: The Deconstruction of Christianity II*, trans. John McKeane (New York: Fordham University Press, 2013), 78.

2. Gérard Granel, "Far from Substance: Whither and to What Point? (Essay on the Ontological Kenosis of Thought Since Kant)," in Jean-Luc Nancy, *Dis-Enclosure: The Deconstruction of Christianity*, trans. Bettina Bergo, Gabriel Malenfant, and Michael B. Smith (New York: Fordham University Press, 2008), 163–74.

3. Philippians 2:7.

4. Granel, "Far from Substance: Whither and to What Point?" in *Dis-Enclosure*, 163.

book.[5] When one speaks about political concepts in terms of secularized concepts like Schmitt, one borrows a schema from the Catholic Church and theological representation, the schema of the kingdom of God, one neglects any faith-based relationship to God, and one considers a certain organization. But then, we're perhaps taken beyond what Blumenberg can make one induce; secularization is perhaps nothing more than the reprisal of an entire Christian conceptual apparatus, itself borrowed from models of theocratic sovereignty. Christianity would only be a passing place in time; what remains unknown is what really happens with Christianity. Very quickly, one can believe that one does make out the representation of a kingdom, but this representation is essentially the kingdom of God because the kingdom of the world was only constituted as a secularized kingdom after the fact, copying something from Christian representation. So one probably shouldn't talk about theology because, in the beginning, what one extracts from it is an element of faith. Still, theology isn't faith. There can be a theology of faith, but this kind of theology has never provided faith; a theologian of faith can be a complete non-believer or infidel in the end. If one takes an element out of religion, it may no longer have a sense. If one extracts "kenosis"[6] from its context, as Gérard Granel suggested, is

5. Jean-François Kervégan, *Hegel, Carl Schmitt: La politique entre spéculation et positivité* (Paris: Presses Universitaires de France, 2005).

6. *Kenos*, in Greek, signifies "empty"; Kenosis, "emptying out." Paul teaches (Philippians 2:7) that Jesus, named Lord, "emptied himself" (*heauton ekenōsen*), annihilated himself to the obedience of death on the cross. In Luther's Bible, *kenōsis* is *Entäusserung*; this term was credited to Hegel in philosophy: The absolute Idea empties itself like the Verb does, one could say.

there any sense in speaking about God "being emptied" of its deity in order to become a man outside of Christ, who was precisely this god who joined humanity completely? More simply, can one hold on to the term kenosis outside the context of creation and incarnation?

Now as for the second part of the question: Isn't there in the very principle of Christianity, that is, beneath what Christianity displays, beneath what one can read in the entire tradition that began with the crafting of the Christian texts such as the Gospels, the Acts of the Apostles and the Epistles and Christ's elaboration and representation, isn't there, then, something that at the same time was shaking the entire philosophical edifice and taking over Christianity itself? Stoicism was already operative in Paul, for example. Christianity, in its beginning, was considered by many to be a philosophy, and thus a movement that separated itself from the entire philosophical edifice and from all the religious groups in their relationship to a higher power and a higher ability to receive the complaints and the offerings of man at the same time, that is, a power that belonged to a logic of sacrifice in one way or another. Is this not what's at stake in Christianity, which is perhaps the sacrifice that puts an end to all sacrifices, in the words of René Girard? Certainly, abandoning human sacrifice in the entire Eastern Mediterranean arc between the thirteenth and the ninth centuries[7] is a phenomenon that radically changed something in the culture, or civilization, of that part of the world at least.

P.-P.J.: Alongside these remarks, one might recall that the emperor Constantine did not forbid paganism, nor did he

7. Some of these practices had survived up until the time of classical Greece, which is indicated by laws forbidding them. Yet from then on sacrifice belonged to what was banned.

take measures against pagan practices. He always supported the values of Christianity through speech and he began to establish the power of the Church, not only by offering it material support, but also in his refusal to participate in the part of the ceremonies—which he was required to attend due to his position—that dealt with sacrifice and blood.[8]

J.-L.N.: A very interesting and impressive attitude to have . . .

P.-P.J.: If, according to Paul Veyne, Constantine was the "president of Christianity" who notably ensured that the fundamental points of the dogma were established, what gets forbidden was established after the entry into another dynasty, the dynasty of Theodosius.

J.-L.N.: Yet what does "abstaining from sacrifice" and even "abstaining from blood" suggest if not recognizing the possibility of establishing a bond with another world that's held to be sacred? It seems to me that from that moment on, in the depths of Christianity, there is something like the germ of the disappearance of the sacred that had its roots in Judaism perhaps; here one can refer to what Levinas talks about in the passage from the sacred to the holy.[9] The sacred is the separated, delimited order, which one can only access through certain procedures that are actually of a sacrificial nature. On the contrary, the holy, in a certain way, is not a separate order at all; this almost brings us back to the question of immanence. In Christian terms, the saint or holy person is the sinner who knows themself to be a complete sinner and

8. Veyne, *When Our World Became Christian: 312–94.*
9. Emmanuel Levinas, "From the Sacred to the Holy: Five New Talmudic Readings," in *Talmudic Readings*, trans. Annette Aronowicz (Bloomington: Indiana University Press, 1994).

confides in God as such. Confiding in God, this person becomes holy, and participates in the divine condition.

P.-P.J.: Still, taking up Levinas, one can find another character, the "Messiah." In one of his talmudic readings, Levinas, after having commented on a text concerning messianism, comes to this conclusion: "The Messiah is Myself; to be Myself is to be the Messiah."[10] I understand that the Messiah, in a certain way, is anyone.

J.-L.N.: That the messiah may be anyone is consistent with the thought of Christ as a man among others, like all the others, nothing more than the others; there's an entire vein of "demythologized" Christology, which amounts to saying that Jesus Christ is every one of us. One could then say that Christianity does constitute a movement, an operation that completely leaves religion behind—if religion must involve a relationship to the sacred. It's completely desacralized religion, which in a sense has been understood by modern society because it's secular. But, on the other hand, we're confronted by a difficult problem: Can we be satisfied with desacralizing in this way? Is Christian behavior tenable as something that completely abstains from any relationship with the sacred? Is what was tenable for Constantine tenable for entire peoples and crowds? These are questions one could obsess about . . . Because I see very clearly that the religious seeps in from everywhere; I'm conscious of the fact that we're always somehow failing the millions of people who are unable to live in anything but religious society whether they be Muslims or Catholics, especially the Catholics of South

10. Emmanuel Levinas, *Difficult Freedom: Essays on Judaism*, trans. Sean Hand (Baltimore, Md.: Johns Hopkins University Press, 1997), 89.

America, who, living in very different circumstances and political regimes, feel this need. We know, of course, that a thought such as "liberation theology"[11] could appear within these populations. Nevertheless, the rather awkward question is asking whether this is always an intellectual exercise that's feasible for people constituting a certain elite and not for others . . .

What's an intellectual, then? In the positive sense of the word, it's someone in the realm of what we call thought, but who finds themself extremely lively, I'd even say corporeal, within it—it's someone for whom words and ideas are not only words and ideas but the circulation of the real. Perhaps it's typical that this movement cannot be put into social, general circulation without any intermediary? A big question then . . . It remains the case that, in spite of everything we've just said, one hardly sees how humankind could simply go back to the sacred now. In the modern human's general relationship to the world and to itself, there is, despite it all, a technicity, an implied objectivity, which is attested to by what we call science, and which can neither be overthrown nor suppressed. Perhaps the very grasping of what we call technology, reason, rationality, and so on will be transformed, but if this is the case, I don't think that it will be in order to go back to some form of the sacred. It can only be a transformation that gives place to something truly unprecedented, and it seems to me that at this moment

11. In 1968, at the occasion of a plenary meeting of the bishops of Latin America that took place in Medellín, Gustavo Gutierrez used the expression "liberation theology" for the first time, which was later used as the title of his 1969 essay "Toward a Theology of Liberation" (in *Liberation Theology: A Documentary History*, ed. trans. Alfred T. Hennelly, S. J. [Maryknoll, N.Y.: Orbis, 1990], 62–77) and his 1971 work *A Theology of Liberation*.

this emergence would take place in what Christianity would conceal as its obscure content, that is, in the vein of the divine that becomes entirely human, which has to be understood as an opening in the human being of the human being to itself and to a dimension that completely exceeds what we call the worldly, material, sensible, etc. dimension, but exceeding the human from within, making understandable, as Wittgenstein says, that creation is the world existing. In another sense, one could say that within this lies an opportunity to recover the possibility of admiring, of adoring that the world exists, and the fact that I exist, that you exist.

The Quest for "Art"

P.-P.J.: In *The Truth of Democracy*,[1] you indicate that one has to have the expectation that political power knows how to limit itself, that it no longer assumes that the community is a totality, and that it creates spheres in which the heterogeneity of singulars can unfold. You name these spheres: "thought," "desire," "art," and so on. I'd like to ask you a question about the situation of art today, in which "today" designates, in your own words, "a time in which the notion of art is no longer interconnected with the notion of cosmos or the notion of polis." In your view, then, what appears in what we sometimes call the crisis of art?

1. Jean-Luc Nancy, *The Truth of Democracy*, trans. Pascale-Anne Brault and Michael Naas (New York: Fordham University Press, 2010).

J.-L.N.: I do think that the crisis of art displays the decomposition, if not the rotting or certain disrepair or disassembling of something that was held to be a cosmic and cosmetic[2] order until our time, or perhaps until the so-called "world" wars—though geographically they were not exactly that. This good and beautiful order, as it was thought about from the perspective of Europe or the United States, usually presented itself in the form of the nation-state. Besides, at the time of World War I, this order of the City, which could be monarchical while also already taking on a republican or democratic form, began to crumble. Here we can't avoid returning to Hegel, to whom one always attributes the phrase that suggests art is dead or over, but whose actual words are that art is "a thing of the past." With this expression, Hegel wanted to say that art as a representation of the truth, as the bearer of the representation of a general layout, was over, and I think he was spot on.

As a result, he made it possible and necessary to remove art from this function of representing a cosmetic cosmic; this, one could say, is the positive aspect of Hegel's legacy. As a result, art began to grasp itself in a stripped down, essential fashion, in something very simple or fundamental: what's at stake in art initially is not transmitting the representation of a world or an order (natural, social, and so on); art consists of the gesture of taking sensation to a particular intensity. What is music but the intensification and the selection of sound in noise? I'm borrowing this idea of "intensification" from André Schaeffner—in his *Origine des instruments de*

2. We might recall that "cosmic" and "cosmetic" have the same Greek etymology; the verb *kosmein* and the noun *kosmos* contain the idea of order and beauty at the same time.

musique [*Origin of Musical Instruments*],[3] and in this intensification of the sensible, I tend to see the mark of desire, not in order to represent a world, but to bring out an order whose sense is close to "form" here (one "brings out a form"), a term that also indicates beauty in Latin (*formosus* signifies "beautiful").

As for the negative aspect, in the almost complete absence of cosmic or political order that could be represented, the situation of art today is one in which art finds itself confronted by the complete absence of beauty, that is, what points out or indicates beauty. On the contrary, art can claim ugliness, horror, or the ridiculous. I find the development of Mickey, or rabbits with big ears installed in Versailles by Jeff Koons, extremely striking in contemporary art, as well as the development of horror, disgust, and self-mutilation by David Nebreda or, perhaps a little less violently, in the works of Orlan. All of this is a deliberate resort to what can only appear as the opposite of a beautiful form because for us, in any case, the beautiful is somehow always inseparable from what we've been habituated into calling beautiful—a certain canon, certain proportions, certain harmonies. Speaking of which, it's interesting that all of these forms of contemporary art, whether they are plastic or musical, are reserved for a much smaller audience than the audience who goes to retrospectives of more classical art: Monet, Matisse, and Artemisia are the most visited exhibitions in Paris at the moment. There are certainly people at the *documenta* in Kassel or the Venice Biennial because they're international exhibitions, but it's not possible to compare this phenomenon

3. André Schaeffner, *Origine des instruments de musique:*
Introduction ethnologique a l'histoire de la musique instrumentale (Paris:
Payot, 1968).

to an exhibition in which visitors, by their number, bear witness to a certain nostalgia for an art in which one recognizes the idea of a beautiful form. This is the "negative" aspect of what comes after Hegel . . .

P.-P.J.: When you speak about intensification concerning sounds, is it analogous to what you call "the pleasure in drawing"?[4]

J.-L.N.: Yes, very much so. The "pleasure in drawing" also consists of isolating and intensifying the completely natural gesture of leaving a trace. Maurice Blanchot's text on the origin of art says it admirably well: One either sees the traces of the bear on the walls of the cave, or it's the human being itself who leaves a trace of its dirty fingers, or it's the immaterial trace of smashing flint into pieces, which generates the pure pleasure of smashing something into pieces. Nevertheless, for me, it's preferable to say all of this in terms of Kant: "Fine art is the art of genius,"[5] and he specifies: "Genius draws from the very source of nature."[6] Let's say it like this, even though this isn't a self-evident thought. It's like another creation, a recreation of the world and when there isn't actually a creator or organizer of the entire world anymore, then this gesture becomes detached for itself, but this gesture has always been the gesture of art, of opening the possibility of

4. Jean-Luc Nancy, *The Pleasure in Drawing*, trans. Philip Armstrong (New York: Fordham University Press, 2013).

5. Immanuel Kant, "Fine Art Is the Art of Genius," in *Critique of Judgment*, trans. Werner S. Pluhar (Indianapolis: Hackett, 1987), 174.

6. [Nancy appears to be paraphrasing or quoting Kant's *Critique of Judgment* from memory. See, for instance, "Genius [. . .] as nature [. . .] gives the rule," in Immanuel Kant, *Critique of Judgment*, trans. Werner S. Pluhar (Indianapolis: Hackett, 1987), 175—Trans.]

an ordering. And I think that one can say that the human being is the one who has to bring out a world, both as a form and as sense, or as language.

P.-P.J.: The form we're speaking about is the form one gives to matter, to a sound. The word "form" is also a possible translation of Plato's "idea."

J.-L.N.: Yes, that's right.

P.-P.J.: What underlies this is perhaps a hierarchy or a distinction in any case between intelligible and sensible forms.

J.-L.N.: We should be wary of how we're accustomed to interpreting Plato because the way we read this author is always a little biased and filtered through Neo-Platonism, Christianity, and so on, so that when we speak of "forms"—while being wary of the expression "intelligible form," since "intelligible," at least, is not a word from Plato—we find ourselves referred back to some sort of ethereal realm, whereas if the ideas are "forms," it also means that they are sensible. This is why I was just speaking about sensation and the sensible. But later I was planning to try and displace, or perhaps nullify, the distinction between the sensible and the intelligible in order to say that the gesture of art consists in a "form," let's say a mode of intelligibility, which is not conceptual, abstract, or logical (however one wants to put it). Modern art is a way of referring to this elementary gesture of intensification—a very sensible approach in two areas, painting and music. Contemporary art—let's say art since the beginning of the twentieth century—did go on to promote color considerably to the point of creating monochromatic paintings, or at least abstract paintings with one or a few colors: I'm thinking about Rothko, Barnett Newman, Twombly, and so many others. One finds something that had never been done in this, or at least made visible as such

in art: to do color for color's sake, to prompt colors to play with one another, to produce a color for its own value. Yves Klein, for example, fabricated his own blue.

P.-P.J.: He even patented its formula.

J.-L.N.: It is, in fact, a very singular blue. The great difficulty with colors is that one can hardly talk about them with precision; it's a blue that's on the side of ultramarine, but with its own tonality. So on the side of color, it's as if we'd come to grasp an elementary, sensible quality somehow and to make it have a value in itself. A big part of contemporary music—since twelve-tone music, serial music, and then concrete music, and electronic music in between—consists, so to speak, in grasping the birth of sounds, making sound be heard for itself as it is being produced. One might think of Pierre Henry's "Variations for a Door and a Sigh"—which inspired a choreography by Maurice Béjart in 1965 and one by George Balanchine in 1974—but also of Luigi Nono or György Ligeti. The same phenomenon could be observed in the area of poetry. Antonin Artaud's "glossolalia" revealed more than the rage, destructive furor, and self-regenerating fury that were part of his madness. It's a gesture that could probably only take place today: the grasping of language as it's being born.

P.-P.J.: I was also thinking, in a less dramatic and less pathetic sort of way, about the experience of "lettrism" initiated by the Romanian-born writer Isidore Isou . . .

J.-L.N.: As well as Ghérasim Luca, who has the same background . . .

P.-P.J.: Deleuze liked him and cited him frequently.

J.-L.N.: Yes, I like him a lot, too, even if his case is a bit different: "I love you not, I love you not, I love you, no . . . ,

I love you . . ." ["Je t'aime pas, je t'aime pas, je t'aime pass, je t'aime passio . . ."],[7] as if he were plucking a daisy backwards; it's both a stammering that, rather than referring to being completely in love, whether happily or unhappily, refers to the inherent difficulty in the declaration of love itself, and to the babbling of the child who is not searching for their words like when we search for the appropriate term, but rather who is trying to access the word itself. One could find a large amount of evidence of this kind of regrasping of the isolation and identification of a sensible order. In the case of language, it has to do with regrasping a sensible order in which language responds to these words of Paul Valéry: "In poetry, meaning begs for sound." In the end, I wanted to extend this phrase of Valéry to all of art: it's always the case that sense, the sense of the world, the sense that we're in charge of, and which gives us concern and unrest, begs for the sensible in general.

P.-P.J.: What you said about sense and the sensible reminds me of something you said about our current situation: We won't be able to hold on for much longer to the "evident" division between the intellectual and the emotional, between the reasonable [sensé] and the sensible, the sensual, etc. These are distinctions that don't seem relevant anymore, or at least they're being called into question.[8]

J.-L.N.: Absolutely. And these distinctions create a division within what was, or at least what seems to us to have been, the condition of an ancient, archaic person, for whom the

7. Ghérasim Luca, "Passionnément," in *Le Chant de la carpe* (Paris: Le Soleil noir, 1973).

8. This idea was developed at a talk entitled "Au présent," which was given in Paris in January 2012 as part of the seminar "Adoration et phénoménologie" at the Collège International de Philosophie.

intellectual understanding of the world, life, relationships, and so on was unable to be detached from a number of sensible signs and interactions. Of course, one can say that the keystone of such a world was for a long time human or animal sacrifice, and even the sacrifice of the first fruits of the harvest, and that we have become completely foreign to this world. But our distance from this without a possibility of returning to it makes the following question all the more pressing: How does one relate to the world when in the end one is completely divided between the intelligible and the sensible? Contemporary art faces this straining, this quartering, between having no real relation of intelligible understanding to an ordered whole of the world, to common existence, and, on the other hand, having a very acute, raw, and exposed sense of the importance of the gesture through which one brings about a form by intensifying a register of the sensible.

But what is a form? Henri Focillon offers a beautiful definition of it in *The Life of Forms in Art*: "form signifies only *itself*,"[9] unlike the sign, which signifies something. That's what happens in art when one brings forth color for its own sake; in this sense, color is a form in the same way that sound is a form.

P.-P.J.: One does not paint *with* blue, one does not paint *in* blue, one paints *blue*.

J.-L.N.: So, the distinction between sensible regimes appears more clearly and allows us to see something we've always known in a new way—that is, the diversity of senses. The drive for intelligibility, however, represented by philos-

9. Henri Focillon, *The Life of Forms in Art*, trans. Charles B. Hogan and George Kubler (New York: Zone Books, 1989), 34.

ophy in particular throughout the classical age, has always wanted to reduce this diversity of senses. In philosophy or classical thought, a hierarchy of the senses, and thus of the arts, has always been a question more or less. It's not by co-incidence that most often poetry has been given the highest position because it's precisely in this art of language that we're in the realm of intelligibility.

P.-P.J.: It's the least "bulky" materially.

J.-L.N.: Yes, absolutely, and sometimes it's music that's been promoted to this rank, particularly since Schopenhauer, that is, from the moment in which a certain sensibility for pessimistic thinking manifests itself, which gives up on the possibility of enunciating the truth of the senses and which, because of this fact, assigns a particular value to this sound element, just like in the case of speech, but here it's without speech or goes beyond (derives from) speech. Following this will to hierarchize at the end of the nineteenth century—this isn't by chance, either—the idea of "total art" appeared. At the same time, many reflections, which were less about aesthetics and more about esthesiology, questioned themselves about sensibility in general, about synesthesia, about how several realms of sensation correspond, and even about the sensibility that all sensations have in common . . .

Still today, we are, on the contrary, led back toward taking into account once more a fundamental, radical heterogeneity between the sensible orders, which doesn't simply correspond to the five senses that tradition has distinguished. Whatever possibilities are offered by technology in order to multiply or modify senses, whatever pathologies may alter the senses, this remains a matter of the body: eyes, ears, a nose, a mouth, and skin. The sensible orders are defined in this way, and they are never reducible to one another: One will never be able to see a sound. On the other hand, it's also

certain that from one order to another there are many cross-references: One can comprehend very well that when one hears a certain piece of music, one is drawn toward a certain form, or color . . .

P.-P.J.: Are you referring to Kandinsky's reflections on *Klangfarben*?

J.-L.N.: *Klangfarben*, that's it: the idea of composing a melody with colors, each of which works as a sound. It's nevertheless preferable that the project within this enterprise remains at the level of an evocation or allusion, which is true for any sensible experience. In order to avoid the confusion of indeterminacy, in order to play with the cross-references from one order to another, a gap must be maintained. So it's important to insist on the diversity and complexity of the arts, which doesn't stop a work of art from having both auditory and visual aspects, or from taking into account all of the kinds of different qualities of the visible: painting, drawing, film, photography, video . . . One must underscore that by insisting on the truly heterogeneous multiplicity of the registers or regimes of the sensible, we take into consideration the ontological range of what we're after. Affirming the irreducibility of sensible multiplicity and challenging the division between the sensible and the intelligible are closely related because in philosophical discourse there's always the idea that unity goes along with the intelligible and that the sensible is multiple. The intelligible is fundamentally attracted to unity, even if at the same time one could remark that very heterogeneous, intelligible, or intellectual regimes exist: philosophy, literature, art, religion, science . . . One should begin by saying that if this is the case, it's because they're regimes of different "intellectual sensibility."

P.-P.J.: My question about art, about the arts and their irreducible plurality, was based on your work *The Muses*, in particular on a passage in which, after underscoring the heterogeneity of art, you ask: ". . . to conclude, so as not to be finished with it, what if the truth of the singular-plural of art was in fact that the arts are themselves *innumerable*, and of their forms, registers, calibers, touches, exchanges through *mimēsis* and *methexis* . . . ?"[10] Is this the limit of a phenomenology? And a few lines further in your text: "The things of art *are* not a matter for a phenomenology—or else, they are themselves phenomenology, according to an altogether logic of this '-logy'—because they are in advance of the phenomenon itself. They are of the patency of the world."[11] This notion of "patency" often reappears in your thought, for instance, in *The Sense of the World* . . . [12]

J.-L.N.: Yes, it's true that I like this word "patency," even if it's a bit heavy. In fact, I found it in Spinoza in his expression: "*Veritas se ipsam patefacit.*"[13] And I willingly speak of "patency" because "patency" means something evident, an evident manifestation, a showing or "monstration."

P.-P.J.: The word may be a bit heavy, nevertheless, "patency" is the opening, *patere* is to be open.

10. Jean-Luc Nancy, *The Muses*, trans. Peggy Kamuf (Stanford, Calif.: Stanford University Press, 1997), 32.

11. Nancy, *The Muses*, 33.

12. Jean-Luc Nancy, *The Sense of the World*, trans. Jeffrey S. Librett (Minneapolis: University of Minnesota Press, 1997).

13. Baruch Spinoza, "Treatise on the Emendation of the Intellect," in *The Ethics; Treatise on the Emendation of the Intellect; Selected Letters*, trans. Samuel Shirley, ed. Seymour Feldman (Indianapolis: Hackett, 1992), 243.

J.-L.N.: You're right—this is the sense of the Latin *patere*. So, "*Veritas se ipsam patefacit*" means "truth reveals its own self"[14] and this is what makes art. In the end, I'd even twist my words to say that art comes from the fact that it is not a particularly refined type of operator. I'm thinking about the objections that Jacques Rancière in particular always puts forward to what he considers to be an unnecessary resort to an overessential, superb, metaphysical idea of art, which shouldn't be invoked, according to him. Still, I don't see very well what he'd do so differently if he held onto the false representation, according to which, when one says "art," one appeals to a superior virtue, a sort of religion even, of religiosity—which used to exist, it's true. But this isn't the question: the opening of the truth of the world, of things, of Being—however one might say it—is particularly manifest by the fact that man is compelled into this gesture of intensification of a sensible regime in order to bring out a form. If one thinks about a man drawing a line on a wall, who starts playing with his voice, not just speaking, perhaps already singing, we're no longer in the realm of phenomenology or we're "in the place of" or "replacing" phenomenology, but not in the sense that Husserl gave to this. We're not presupposing a subject or an object, or a phenomenon as an "object coming before a subject." It's a question of, more mysteriously, the fact that suddenly, within a certain being, *Dasein*, as Heidegger would call it, the world itself shows itself. I'd almost like to say that the world shows itself to itself entirely. Including the world that exists before the human being and which is only there through the human being: It's also we who manifest the dinosaurs, the ice ages.

14. Ibid. English translation modified—Trans.

P.-P.J.: At times you've mentioned when speaking about Schelling that, in the end, through the human being, nature expresses itself.

J.-L.N.: Yes, exactly, Schelling speaks about the "tautegory of nature," about nature enunciating itself.[15] And I'd like to be able to say—without being in too much of a metaphysical phantasmagoria, or even, sure, to take this provocation further, to be in a phantasmagoria rather than in a phenomenology—that the entire world tries to speak itself out or rather to *patefacere* itself, to show itself, to open itself, that is, to declare itself for what it is. This would amount to saying that there's never a thing that's entirely deprived of a world, simply standing there, that is. Because of some schematics of "physics," things are different from how we're used to seeing them: the big-bang, then all sorts of living beings, then the living that speaks, that symbolizes, that produces forms . . . In fact, the entire world has never stopped looking for an expression.

One can say, through the double value of the genitive, that the human being is both the expression *of* the world and the world*'s* expression: The human being is the inhabitant of the world, but at the same time, it transforms the world deeply through its *technē*, its technology, what in Latin gets translated as *ars*, its art. It seems difficult not to say, along with Heidegger, that technology is the last "sending of Being," which means that the enormous technological machinery without which we can no longer live isn't simply a group of supplements, tools, and instruments, but testimony of a complete remodeling of the world. This machinery isn't only

15. F. W. J. Schelling, *Historical-critical Introduction to the Philosophy of Mythology*, trans. Mason Richey and Markus Zisselsberger (Albany: State University of New York Press, 2007).

pregnant with catastrophes as Heidegger saw it—it really is, nevertheless—it also renders manifest this human capacity to give oneself another world. Still the relationship of the human being to the world isn't the relationship of a subject to an object, of a subjectivity to an objectivity or an objectness [*objectité*]. The phenomenon of the world doesn't quite have to be taken as the appearance of the world to the human being, to a subject, a consciousness; the world itself is the phenomenon—if one wants to retain the word phenomenon because it always runs the risk of being on the side of an appearance that's distinct from reality. Here I'd like to make a reference to a certain passage in the last text that Philippe Lacoue-Labarthe wrote, the "Postface" of his posthumously published book, *Préface à "La Disparition"*: "this world in its entirety, which is because it appears, without any exceptions."[16] A few lines further, he indicates that "the condition of poetic existence (. . .) is not to get beyond appearances (there are no appearances exactly) but to take the risk of standing in the place, at the point of the origin of appearance, which is everything." Nevertheless, one should indicate— and this nuance is fundamental—that one can't speak about a world in which everything only appears. Nothing happens in a world that would be a container. It must be understood: "The world is the fact that it appears" and one could return here to Wittgenstein's well-known expression: "Creation is that the world is here."[17]

16. Philippe Lacoue-Labarthe, *Préface à "La Disparition"* (Paris: Christian Bourgois, 2009), 45–46.

17. [Nancy is paraphrasing the opening of Wittgenstein's *Tractatus Logico-Philosophicus*: "The world is all that is the case." Ludwig Wittgenstein, *Tractatus Logico-Philosophicus*, trans. D. F. Pears and B. F. McGuinness, with an Introduction by Bertrand Russell (London: Routledge & Kegan Paul Ltd, 1961), 5.—Trans.]

P.-P.J.: In the passage from *The Muses* that we were referring to, there's mention of a *lux* without *fiat*,[18] without any creator subject or source, but as the source itself diffracted, radiant, explosive, shattered, a *lux* that one could almost say is anterior to any *lumen*.

J.-L.N.: In any case, like the text you've read says, it occurs without *fiat*.

P.-P.J.: At the same time, to say that creation is that the world appears, this implies saying, since it isn't a question of the manifestation of something that would be "behind" something or the manifestation of something that would "appear," because it can only be a question of a plurality that co-appears, in the double sense of phenomenality and justice (in German, this is said in one word: *Erscheinung*). It's logically connected.

J.-L.N.: Absolutely, yes.

18. "Lux fiat" ("Let there be light") is the Latin version of God's speech creating light (Gen. 1:3); *lux* designates light's brightness, its outpouring; *lumen* signifies the light in which we "bathe."

The Present, Presence

P.-P.J.: There are two notions we should touch upon now based on your work *After Fukushima: The Equivalence of Catastrophes:*[1] the present and presence. In the analysis of what is mistakenly called a "news clip"—a testimony to a world that has become what you call "struction" in your most recent book, *What's These Worlds Coming To?*[2]—we're encouraged to depart from a thought of crisis and planning, that is, from a certain vision of temporality and history. This change might lead us to distinguish between two senses of the present: the present as it's been criticized in the

1. Jean-Luc Nancy, *After Fukushima: The Equivalence of Catastrophes*, trans. Charlotte Mandell (New York: Fordham University Press, 2014).
2. Jean-Luc Nancy and Aurélien Barrau, *What's These Worlds Coming To?*, trans. Travis Holloway and Flor Méchain (New York: Fordham University Press, 2015).

"metaphysics of presence" (being present to oneself, etc.) and the present that should be taken into account more seriously in the sense of what is ephemeral, in the words of Haruki Murakami, the Japanese writer you cite. In other words, has the moment come for carrying out a displacement of our thought, from a problem of time to a problem of space?

J.-L.N.: Yes, a problem of space as in spacing, which may also be the spacing of time, which even our own Western tradition knows very well. All of us have in mind these lines from Lamartine: "O time, suspend your flight, and you, auspicious hours / Suspend your sequence on: / Let's savor the rapid, evanescent delight / of beauty's finest hour"—words pronounced by the woman whom the poet loves.[3] It's the request that the flow of time be interrupted, if you like, and this interruption is not a cut or an absence of continuity, but the suspension of the continuity through which it can present itself to itself. The female lover implores for the suspension of time, for spacing instead of the haste of successive moments, which end up nullifying the present moment. It's often been noted that the present moment—the *nun* of Aristotle and the *jetzt* of Husserl—is not even ephemeral, it's what does not take place, and in it the present is the extreme tension between what Husserl calls "protention" and "retention." Here we have a fundamental experience of the Western world's constitution, an experience that keeps step one moment after another, thus giving rise to the impossibility of seizing a "now," of "savoring" it, as Lamartine writes, condemning one, one could say, to what keeps one from enjoying the present and that then turns the present into what in

3. Lamartine, "Le lac de B . . ." in *Méditations* (Paris: Éditions Garnier Frères, 1968), 48. [Our translation—Trans.]

effect has been disqualified as the "metaphysics of presence" since Heidegger. But in this metaphysics, presence is actually considered to be something thrown on the shores of the river of time and that remains there in a sort of abandoned immobility. This is what Heidegger calls *Vorhandenheit*, that is, "Being-present-at-hand" [*être-là-placé-devant*], a dense, motionless, silent, insignificant thing, to be differentiated from something "ready-to-hand" [*sous-la-main*] that is available for the activity or project of an existent, or what Heidegger calls *Zuhandenheit*. But one could say just as well that presence in this sense, even with the distinction between the two nuances, is not present at all or is present only for the existent that has it at its disposal.

Still, one can understand presence in a completely different way as being intimately connected to manifestation or appearance, as we were saying, in the same sense as when one says that someone has a "presence" or that certain actors have a particular "presence," which means the exact opposite of a thing's presence. In this case, this presence is a "coming" (one "comes into the presence of"), an "appearing." In reality, one retains the use of the word "presence" for what happens between everyone; when people grace each other with their "presence," a relationship gets created. If there's no relationship, there's no presence, because being present means showing up or "presenting oneself" (of course not in the sense of a simple "social obligation" [*mondanité*]). This specific presence [*présence-là*] is probably always somewhat ephemeral in the sense that when one shares their life with someone, as one says, there are moments of absence and moments of presence. And one must show up [*se présenter*], in the sense of paying attention, in order to show that one is paying "attention to," but not out of a sense of obligation—a pretty dry way of behaving in general—because it translates something which can actually only be done without a maxim

into a maxim. This presence as "presence to" asks for a gesture and this gesture is subtracted from the flow of time, from pure succession; it removes, in effect, moments from time, and in a sense, it is ephemeral. But this non-duration is, at the same time, something that pervades duration itself. So we find ourselves in the realm of the ephemerides, which we pay very little attention to in general; the succession of days has for itself something cosmic, cosmological, and it's also the succession of "everyday" continuation or of a way of coming into the world. Every morning, one comes back to the world after being truly absent during sleep, which is connected to this poor, physiological, biological truth: Without sleep, one can't live for long.

P.-P.J.: One can't help but mention here the ambiguity in the title of your work *The Fall of Sleep* [Tombe de sommeil].[4]

J.-L.N.: Of course, but it's a book that remains very much on the side of the "aesthetic" instead of the metaphysical. In the end, I think it's a very significant fact that we have to become absent from the world and ourselves in order to come back to it everyday, that is, according to a rhythm that's also the rhythm of day and night.

P.-P.J.: A little like when one says, in other circumstances, "I had a close call," when one has come close to dying; but after all, death is often viewed as a "final resting place" or an "eternal sleep" . . .

J.-L.N.: Yes, one has a close call every day and so, in a very sensible way, the present of waking up or falling asleep is the

4. [In Nancy's *Tombe de sommeil*, "*tombe*" may be translated as either "fall" or "grave"—Trans.] Jean-Luc Nancy, *The Fall of Sleep*, trans. Charlotte Mandell (New York: Fordham University Press, 2009).

present of a distancing, a distention of time; one is no longer really in a succession, but in either an inauguration or a closure or conclusion. Time continues but as Kant says so well, "everything passes in time, except for time itself." I'd say "time itself" is the *tempo*; there's a very important question of rhythm here.

P.-P.J.: Speaking of rhythm, Jacques Derrida offered a commentary on the "blink of an eye," which you took up. One is actually tempted to say that time passes "in the blink of an eye."

J.-L.N.: Yes, but the blink of an eye takes time, as Derrida said about Husserl's *Augenblick* in *Voice and Phenomena*.[5]

P.-P.J.: The blink of an eye takes time, so one returns to oneself all the time. One is always in this coming, this repetition of the coming that one mistakenly calls "presence."

J.-L.N.: I think there's something very important here because you were speaking earlier about the possibility of "subtracting oneself" from thinking of the plan as well as the crisis.

P.-P.J.: Allow me to briefly quote from *After Fukushima: The Equivalence of Catastrophes*: "Our thinking must no longer be either about crisis or plan. But we know no other model for thinking about the 'better.'"[6] A few pages further you say, "What would be decisive, then, would be to think in the present and to think the present."[7] Finally, you

5. Jacques Derrida, *Voice and Phenomenon: Introduction to the Problem of the Sign in Husserl's Phenomenology*, trans. Leonard Lawlor (Evanston, Ill.: Northwestern University Press, 2011).

6. Nancy, *After Fukushima*, 35.

7. Ibid., 37.

mention Haruki Murakami's speech in June 2011 on the occasion of the ceremony that's called *hanami* in Japanese: "'we cherish the cherry blossoms of spring, the fireflies of summer and the red leaves of autumn'—to contrast with the irremediable destruction 'of ethics and values.'"[8]

J.-L.N.: It's true that this thought and the actions that it alludes to seem meager, fragile, and absolutely measly to us in comparison to the Fukushima catastrophe as well as to the very necessity of making plans to prevent these kinds of events from happening again. But at the same time, if we make only these kinds of plans, we unequivocally hold onto a finality, the finality of energy, the finality of a certain development, the finality of a certain growth, and so we continue on with all of the civilization that has produced this vision of the world. I'm not saying that one should give up on all plans in order to live day-to-day, and to give ourselves over to what some have called a "presentism." The question isn't to relate to a future in the sense in which the latter, as Derrida says, is a present-future that has already presented itself. If the plan consists in representing to ourselves what will be, what must be, what we must make come, then the present, the present of the *Vorhandenheit*, of the "deposited" thing, has already affected the future. If, on the contrary, one stands in the present as something ephemeral that only passes by and is fragile— the mayfly insect is called an "ephemera" because its life lasts for a day—then one remains attached to duration, and one winds up once again entrusting everything to a projection of what's to come, which ultimately makes it present in advance.

8. Ibid., 64.

P.-P.J.: As if we wanted to have a guarantee [*assurance*], in every sense of the word . . . I would suggest translating "ephemeral" as "fortuitous."

J.-L.N.: I agree, and incidentally in *Adoration*, I chose the word "fortuitous"[9] because I like what it evokes: the ephemeral, but also chance, evanescence.

P.-P.J.: What interests you about the "fortuitous" is that it's not a question of necessity or chance. One can find in your works many examples of this writing strategy, that is, in this approach to thinking: its economy of "neither . . . nor . . . ," if one may put it this way. We aren't in the *coincidentia oppositorum*, nor are we in a dialectical logic; we are trying to go "between" . . .

J.-L.N.: Probably, even though this practice in my writing isn't intentional. It's tempting to compare this turn of phrase, "neither . . . nor . . . ," with Maurice Blanchot's "neutral" because the neutral (*ne-uter*) is "neither one . . . nor the other . . ." But perhaps Blanchot makes the neutral into too much of an authority, "The Neutral." I'd say more simply that the use of this trope, "neither . . . nor . . . ," is imposed by a situation that we're in, a sort of extremity of signification's possibilities; we always seem to oscillate between several possibilities, none of which are truly satisfying. So to think about what's to come isn't a question about the future, as we were saying, nor about a "coming" that one would be waiting for endlessly. Derrida's "différance"[10] might offer

9. One may also read the article "Fortuite, furtive, fertile" in the journal *L'Étrangère* 26/27 (2011).

10. On the word "différance," one may read Jean-Luc Nancy's article "La *différance*, ici et maintenant" in *Le Magazine littéraire* 498 (June 2010).

some help, on the condition that one avoids the misinterpretation of seeing a simple delay or an indefinite procrastination in it. In fact, we have few means at our disposal to express this "coming," which is really placed within the course of time, day after day, and which, at the same time, isn't found in the simple indifference and the leveling out of the everyday. We're in between two formulations: "nothing happens" and "it will happen later."

P.-P.J.: So neither advent nor event?

J.-L.N.: I'd say both are there. And so, it wouldn't be "neither . . . nor . . ." but "both . . . and . . ."; "event and advent," because in any case there's "-vent," if I can put it that way, there's a "coming" [*venue*]. This is largely responsible for establishing the category of the event in Deleuze, Derrida, Badiou, or Claude Romano. There's already the beginning of an analysis in Hegel when he speaks about *Geschehen*; I talk about it at the end of *Being Singular Plural* . . .

P.-P.J.: The surprise of the event.

J.-L.N.: Yes, exactly, the idea of surprise is very important for our purposes. Surprise is what one doesn't expect. I know Heidegger wrote a lot about surprise, wonder, and marveling before Being. But the accuracy of his remarks doesn't stop him from overloading this notion too heavily, perhaps to the point of making it a sort of appeal, to make something come to pass [*faire advenir*], which can be something dangerous. It's possible that this is a form of what one calls "messianism," which is probably why I've always been a bit uncomfortable about Derrida's proposal to speak about a "messianic without messianism." A bit uncomfortable because I could hardly see how to really dissociate the two notions, even if there are two distinct notions in "-ic" and "-ism." Sure, I understand that the second term implies a

system, an entire and homogenous content of thought while the first alludes to a character, a trait . . . Derrida wanted to indicate that there's perhaps a "messiah" trait that's inherent to all of the Western world, a disposition turned toward a "coming about" [*survenue*] or even a "coming to pass" [*advenue*] but not a predictable or programmable one. Which is certainly accurate. But I told him that the sacred characteristic of the Messiah (the one who is anointed by the Lord) to me seemed too attached to the word or name (which Islam has maintained, and which Christianity has Hellenized into *Christos*). Still the "coming about," the event that comes from no process, approach, or necessity, remains to be thought. This is certainly why we're more attentive today to contingency. (I'd like to use this occasion to point out a recent work that I think is important in this regard, *La Contingence du présent*, a thesis by Sandrine Israël-Jost that's not yet published.)

Nihilism or Joy

P.-P.J.: Our—final?—question is about nihilism and joy. Can one hear in "the possibility of a world," the expression that seals our interview, an interrogation into the hope of exiting out of nihilism, which would mean being done with this world that's ending and which has an affective tone of, in the words of Günther Anders, both hopelessness and the desire for revolution?[1] Could one consider a world of joy— I'm aware of the Christian connotation of this expression—in the sense in which you write that "there is not much joy in the human of humanism"? Must the "retracing" of the limits of the political leave room for the opening of spheres where joy would be possible?

1. Günther Anders, *Die Antiquiertheit des Menschen* (München: Beck, 1956).

J.-L.N.: One should think about the appearance of the theme of joy in Christianity. Perhaps one must understand that Christian joy comes in a place left empty, the place of the wise person, and responds to a dissatisfaction, a lack of serenity. The era in which Christianity appeared was profoundly marked by Stoicism, the influence of which is very present at least in Paul. Yet Stoicism or Epicureanism, a bit like its companion or twin, already has in view perhaps like all of philosophy before it—a kind of fulfillment in a wisdom that bears two aspects: both an intellectual dominance or—if one wants to avoid using such a reductive word—a privilege attributed to *logos*; and a certain disappearance, a certain effacement of *erōs*. It's true that in Plato *erōs* seems consubstantial with *logos*. Still, whereas it's very present in the *Phaedrus* and the *Symposium*, it makes itself scarce in the rest of Plato's works. By Aristotle, it has completely disappeared, just as in Stoicism and Epicureanism. Then something else comes—joy?—in the place of what, I would say, had almost been closed off by *sophia* and *theōria*, as well as ecstasy and exaltation, which used to accompany the sacrifice that by then had disappeared—recall that the story of Abraham, as well as that of Christ as the last sacrifice, speaks of this disappearance.

P.-P.J.: We could also speak about the loss of "enthusiasm" that's in question in *Adoration*.

J.-L.N.: This more or less sacrificial, ecstatic, and mystical enthusiasm was present in all the mystery religions that existed up until Rome, at which time they lost much of their power. The entire history of Antiquity until Christianity is perhaps that of the weakening of these mystery religions, which were still present in Pompeii but didn't manage to structure society. As for civil religions, they had also declined, if not failed. Christian joy was perhaps the name of

what came to that place, of a wisdom or a certain enthusiasm that from then on seemed insufficient or unsatisfactory. Christian joy took up this idea of participating in the divine and this quest for plenitude, but by saying it with the sign or mark most proper to monotheism: the infinite. One may think or consider that wisdom or enthusiasm may reach a peak, a final accomplishment, whereas joy is a continuously renewed eruption, which isn't simple or self-evident and is extremely complicated, but which gives it its major key. I'd say then that it's not only a Christian issue because Spinoza wonders about it, too—but perhaps Spinoza wasn't unaffected by Christian or Judeo-Christian influences . . . In the last proposition of the *Ethics*, Spinoza shows how much joy, or "blessedness [*béatitude*]," participates in a dynamic of constant renewal toward a beyond: "Blessedness is not the reward of virtue, but virtue itself."[2] It's vital to understand well that virtue is *virtus*, which is strength or energy (the same is true for the Greek word *aretē*). "Blessedness" is a difficult word to employ today because it seems to designate a "state" more than anything, rather than an impetus, and this is the case, first because there's no semantic group for "joy." And yet *beatus* designates the "blessed" Christian, a titled lower than that of saint. Nevertheless, if one mentions the work of Levinas and, perhaps more surprisingly, Philippe Lacoue-Labarthe's small book, *Pasolini, an Improvisation (of a Saintliness)*,[3] it's hard not to admit that there's an evident and complex kinship between blessedness, saintliness, and

2. Baruch Spinoza, *The Ethics*, in *The Ethics: Treatise on the Emendation of the Intellect; Selected Letters*, trans. Samuel Shirley, ed. Seymour Feldman (Indianapolis: Hackett, 1992), 223.

3. Philippe Lacoue-Labarthe, "Pasolini, an Improvisation (of a Saintliness)," trans. Steven Miller, in *Umbr(a): The Dark God* 1 (2005): 87–92.

joy. At stake in this web is something that isn't wisdom or ecstatic or orgiastic enthusiasm—something that takes the place of it—but rather something that opens another dimension.

In our modern world, this takes the name "happiness." Throughout the eighteenth century, an idea of happiness was developed in the image of a certain bourgeois ideal;[4] one can find echoes of it in Rousseau. What about the emergence of this word in revolutionary discourse, notably in Saint-Just? One may recall the famous declaration delivered before the Convention: "Happiness is a new idea in Europe."[5] Does the novelty consist in an already commonly diffused vision of happiness that would have to be provided to the people through the violence that we know about (the context is that of the organization of Terror)? Perhaps the true novelty would be a thought of happiness less as contentment and more as the possibility in the end of affirming a sense of existence that indeed is not fulfilled or ensured either by knowledge or by a revelation or a religious grace, but through existence itself. My wager, a risky one perhaps, is to attribute some idea of this nature to Saint-Just.

P.-P.J.: To speak of the novelty of this idea of happiness is perhaps also related to the fact that, before the Revolution, the good prince had to be concerned about the salvation of his subjects instead of their "happiness."

J.-L.N.: Yes, completely. Salvation—Christian salvation, actually—may have taken over joy, or taken away from joy, because salvation isn't joyful by itself. Salvation may be the

4. Cf. Robert Mauzi, *L'idée du bonheur dans la littérature et la pensée française au XVIIIè siècle* (Paris: Armand Colin, 1960).

5. A sentence that ends Saint-Just's speech before the Convention on *le 15 ventôse an II* (March 3, 1794).

forgiveness of sins, eternal life, and escaping from hell. Then, evidently, salvation can't be sad or unhappy, but this still doesn't mean that it's joyful. Sure, with law, with good theology, or good Christian spirituality, salvation must tendentially be identical to joy, which means that the saved person is in permanent jubilation to be in the presence of God, etc. But in everyday practice, in ordinary Christianity, Protestantism pushed joy into the background. Then the possibility opens for what you have placed in your expression "nihilism or joy": I like this question's position, which I've never thought about: Nihilism is perhaps the absence of joy before anything else.

P.-P.J.: In listening to you, once again I'm sensitive to the possibility of saying, provocatively, that jouissance is possible in the sense in which you speak about "fulfillment" in *Dis-Enclosure*,[6] and in the sense in which, as opposed to the idea of a "static" nature of blessedness, one may consider a dynamic, an "energetics" of life. Beyond the well-being that's indispensable for maintaining life, there is the possible liberation of a vitality.

J.-L.N.: Yes. And I would even add that I'd like to work on this question of the possibility or impossibility of jouissance. What actually allows Lacan to say that "jouissance is impossible"[7] is to employ "jouissance" in the legal sense of the word, that is, in the sense of the free disposal of a good

6. Jean-Luc Nancy, "An Exempting from Sense," in *Dis-Enclosure: The Deconstruction of Christianity*, trans. Bettina Bergo, Gabriel Melenfant, and Michael B. Smith (New York: Fordham University Press, 2008), 121–28.

7. Jean-Luc Nancy, "The 'There Is' of the Sexual Relation," in *Corpus II: Writings on Sexuality*, trans. Anne O'Byrne (New York: Fordham University Press, 2013).

that I possess; a "static" approach of sexual jouissance, then, is envisioned here by Lacan. Yet this jouissance is exemplary, and perhaps even more than exemplary, because it's precisely in this strange place, as Hegel remarked, that procreation is conjoined to pleasure and one does feel that the explanation of pleasure as the drive of the species falls short. Human beings have always "practiced sex" outside of procreation, even if confining sex to pleasure only did not exist perhaps in more archaic cultures in which procreation itself ran the risk of many dangers. But putting this reservation aside, there remains this strange confluence on which I'd like to work later. We're facing two different situations: Giving birth is not at all the same thing as having an orgasm [*jouir*], even though one has an orgasm in order to or when one wants to have a child. But at the same time, the two things aren't completely foreign to one another: The child leaves, so one can consider the child as a good, but a good that one doesn't possess. And as for jouissance, one doesn't possess it either; it's that in which one is dispossessed; this is why Lacan's linguistic ruse is particularly uncalled for.

P.-P.J.: Sexual jouissance isn't an end.

J.-L.N.: Exactly, but what one says about sexual jouissance one can say also about aesthetic jouissance in general, and also about gastronomic jouissance, too, for example. All the minor arts from this point of view are interesting because the other arts are perhaps at such a height that one feels jouissance less.

P.-P.J.: Sublimated?

J.-L.N.: Yes, that's it, sublimated. But what shows itself in gastronomic jouissance? It's the possibility of making things with food that go well beyond nutrition; but at the same

time, one is nourished by it. So I'd want to say that jouissance is how life shows that the desire to live, which is perhaps life itself very simply, goes far beyond the desire to go on living.

P.-P.J.: Perhaps it's useful here to recall that Freud, in his first theory of drives, which he explains in his *Three Essays on the Theory of Sexuality*,[8] gives a central position to the concept of "anaclisis" (*Anlehnung*): human sexuality develops by "anaclisis" on bodily functions. It's not a question of saying in a banal way that desire relies on need, but rather a question of considering that need always has the opportunity to be exceeded.

J.-L.N.: Speaking of which, in the case of the human being, one cannot strictly speak about need. Except precisely for those who find themselves stuck "in need."

P.-P.J.: What's different from need, and is even opposed to it, is desire . . .

J.-L.N.: Yes, if we understand desire, as we specified earlier, not as a relationship to a lack but as an impetus of existence, as a "push" of Being.

P.-P.J.: But what does this push push toward?

J.-L.N.: Precisely toward the world. What existence strives toward is the world and Being-in-the-world, that is, toward the possibility of making sense. Sense is the reference of all existences between each other, as we said, whether or not it's exactly in these terms. Existence desires to be in the world and to make a world [*faire monde*]. This is done—or at least

8. Sigmund Freud, *Three Essays on the Theory of Sexuality*, trans. James Strachey (London: Imago, 1949).

it must be possible to do so—in each existence, in each instance of existence, by and for each.

P.-P.J.: All the forms of existence.

J.-L.N.: Yes, we discussed this earlier; one must know how to think sense in all its forms, living and non-living. This doesn't mean reducing the human being to a stone or insect, because the human being remains that by which the question of sense, the demand for sense, is opened. But this sense that the human being carries "as such" (through language, through art) itself has sense only in the reference of everything to everything else. A world, then, doesn't proceed from a need—from a being's need or a "creator's" need. A world is without need, a world is this: that everything is here and demands to be greeted insofar as it's here.

P.-P.J.: And evil?

J.-L.N.: Evil is precisely refusing the world, wanting to substitute an empire for it—whatever the sovereign may be . . . This may be the empire of money or "me" or a god, or the empire of technology drunk on itself or piety drunk on itself. One always finds this: the centripetal forces, the self-sufficiencies. The world is centrifugal, erratic, open.